PREHISTORIC
SUSSEX

ALEX VINCENT

AMBERLEY

This edition first published 2023

Amberley Publishing
The Hill, Stroud
Gloucestershire GL5 4EP

www.amberley-books.com

British Library Cataloguing in Publication Data.
A catalogue record for this book is available from the British Library.

ISBN 978 1 3981 1225 4 (print)
ISBN 978 1 3981 1226 1 (ebook)

Typesetting by SJmagic DESIGN SERVICES, India.
Printed in Great Britain.

CONTENTS

INTRODUCTION

Throughout Britain there are many sites of ancient antiquities, from the Palaeolithic (Old Stone Age) to the medieval period. After this it becomes the Industrial Revolution, and this is industrial archaeology. A good many of these sites were excavated over the years and artefacts from them can be found in local museums. The ancient periods are as follows:

Eolithic
This is the dawn of the Stone Age and represents the earliest period when stone tools were first made. The name eolith derives from the Greek *eos* meaning 'dawn' and *lithos* meaning 'stone'. An eolith is a roughly chipped stone found in Tertiary strata. They were thought to be the earliest tools, but are now regarded as natural. They still could have been used as tools, though, particularly if they had sharp edges. This is probably how the art of making stone tools came into being.

Palaeolithic (Old Stone Age)
This period in Britain dates from about 800,000 BC to 9000 BC. The climate was relatively cold and there were only a few months where it was mild and as animals migrated to warmer climes, humans went with them, carrying what possessions they could. For this reason they were not able to establish permanent settlements. They lived by rivers, in caves and on beaches by the cliffs, but they lived a hard life. As the Palaeolithic period was very long, it was divided into three classes. These are the Lower Palaeolithic, Middle Palaeolithic and Upper Palaeolithic.

In Sussex, the Palaeolithic dates from about 500,000 BC. Excavations at raised beaches were carried out at Boxgrove and Slindon, revealing evidence of Old Stone Age activity. Not much of this period has been found elsewhere in Sussex. Where the Palaeolithic sea cliffs once stood like at Highdown 100,000 to 200,000 years ago, the cliffs and any human activity would be buried deep down. Highdown, Ferring, west of Worthing, is the only remaining hill of a stretch of hills that went eastwards to the Black Rock cliffs in Brighton.

Mesolithic (Middle Stone Age)
This period dates from around 9000 BC to approximately 4200 BC. The climate was milder after the last Ice Age ended, which meant that more plants and animals increased in Britain. This meant that humans. although still hunter-gatherers, were able to have more permanent shelters. Despite this improvement, humans still lived a relatively hard but simple life.

In Sussex, Mesolithic sites were mainly flint-scattered sites, where they worked. Some, like at Selmeston, had pit dwellings and others, like in the Weald, were

by rocks, which provided shelter for the Mesolithic folk. A great number of implements and flint tools have been found on these sites during field walking and excavations.

Neolithic (New Stone Age)

This period dates from about 4200 to 2400 BC. Instead of being hunter-gatherers, humans were able to build permanent houses and farmed the land, which was introduced from the Continent. They chopped down trees to grow crops and rear animals. They made tools from flint, which was mined, and learnt how to weave and sew. Before the Neolithic period, Britain was more than 85 per cent covered in woodland. In this period many large stone monuments and henges were erected, like at Stonehenge and Avebury in Wiltshire.

In Sussex there are six known flint mines. Four of these are on the South Downs, north of Worthing. Neolithic people found that flint underground was of better quality than that on the surface, which fractured when struck. Flint occurs in the chalk as seams, and they mined it from the third seam down. These flint mines have been excavated over the past 170 years by many well-known archaeologists. The flint mines were dug using shoulder blades of deer, oxen and pigs as shovels and deer antlers as picks, rakes and hammers.

There are only twelve known long barrows in Sussex, three in West Sussex and nine in East Sussex. There are a few possible long barrows in the county and one of these may have existed at Preston, near Brighton. These would have been bare chalk to show as monuments to people below the hill, but they are just grassy mounds today.

There are only a few known henge monuments and causewayed enclosures in Sussex. The best examples are to be found at The Trundle, near Singleton, in West Sussex and Whitehawk Camp in Brighton. There could be many more of these sites yet to be discovered in Sussex and there is a possible causewayed enclosure on Cockroost Hill, north of Portslade.

Most of their huts in Sussex would have been built of perishable materials such as timber, hides and thatch and would have perished long ago. However, postholes may still exist to show where they once stood and perhaps flints placed in them for stability. A great number of flint implements have been found all over Sussex.

Chalcolithic (Beaker People)

This period is a transition between the Late Neolithic and Early Bronze Age – sometime around 2400 BC. It is also known as the Beaker Period or Copper Age. In the case of the latter, this never really caught on in Britain. There are a few sites from this period in Sussex and one of the best known is Belle Tout, near Eastbourne.

There are only a few known cairn structures in Sussex dating to the Late Neolithic/Early Bronze Age. Some of these are at Belle Tout, Steyning Round Hill, Itford Hill near Lewes and Money Mound at Lower Beeding. Evidence of stone circles and standing stones in Sussex are scanty. Two possible standing stone circles are at Goldstone, Hove and Church Hill, Brighton. A standing stone is thought to have existed somewhere near the Long Furlong, north of Clapham.

Bronze Age

The Bronze Age in Britain dates from about 2400 BC to 700 BC. This is the period when bronze was introduced into Britain. They still made stone tools, which were mainly barbed, and they built a number of round barrows (tumuli) on the downland for their dead. They were of varying shapes such as round barrows, bell barrows, disc barrows and bowl barrows. As with the long barrows, these were bare chalk, which showed up as monuments to people below.

Most of these barrows were situated on the South Downs, but there are quite a number in the Weald. Because the Weald has always been well wooded, it is possible that a great number of barrows and other monuments have long since been buried due to cultivation, heathland areas and woodlands. A great number of tumuli were levelled by the plough during the nineteenth century.

Their huts were either circular or rectangular and built with timbers, mud, clay, hides and thatch. They would have had a central hearth inside for cooking, lighting and warmth. A number of these huts have been reconstructed in museums; one local place is at Butser Hill, near Chalton in Hampshire, which have a few of these reconstructed huts.

Iron Age

The Iron Age in Britain lasted from 700 BC to AD 43. Their huts were built more or less the same as those in the Bronze Age. As the climate was much milder in Britain from the Neolithic period to the Iron Age, people were able to live and work on the downland. The climate started to become less mild from the Late Iron Age/Roman period and people then started to live farther down on the coastal plain.

Most of the hillforts were constructed in the Iron Age period, but some were built in the Late Bronze Age period. They are mainly situated on the South Downs, but there are several in the Weald as well. They consist of banks and ditches and were probably used for defence, to keep animals out or as refuges. A strong tribal society was developed in the Iron Age and the hillforts were probably a stronghold. A univallate hillfort has a single earthwork and a bivallate one has two. Hillforts with more than two earthworks are multivallate.

Pottery was first fired in the Neolithic period, but before this pots were made and left in the sun to dry. Some fired Mesolithic pottery has been found and this is probably due to when their temporary huts caught fire and pottery got accidentally fired. This could be how the firing of pottery, brick and tile was discovered.

On many prehistoric settlements pot boilers or cooking stones were used. Pots were likely to crack when put onto a fire. For this reason, ancient folk used to burn flints in the fire and then put them into a pot of water or soup to heat it up. These stones are known as fire-cracked flints. Plenty of these pot boilers are found all over the place.

A great number of ancient sites can be still seen today in the form of earthworks such as mounds, humps and bumps. Some are only visible as crop marks in the ground at certain times of the year or occasionally. Some earthworks are best seen when the sun is low after sunrise or before sunset due to them casting shadows.

Plaques have been erected at a number of sites giving details of their history. Many sites are now Scheduled Ancient Monuments and the use of metal detectors and digging on them is strictly forbidden.

A great number of sites have been lost due to ploughing and some of these are only visible from aerial photographs. Others have been lost due to development. A number of sites can be visited, but others are on private land and permission must be obtained from the landowner to visit them. In the case of the latter some may be visible from nearby footpaths.

This book gives details about the prehistoric sites in Sussex from the Palaeolithic to the Iron Age periods – what remains are still to be seen, excavations on the sites, etc. It is not a gazetteer of them. All photographs have been taken by the author unless otherwise stated.

1

PALAEOLITHIC

Beedings, Pulborough: Upper Palaeolithic Site
OS Grid Ref: SU 074 203
This Early Upper Palaeolithic site is situated on the site of Beedings Castle (a nineteenth-century monumental house). When the house was being built, a series of fissures were discovered. A stone tool assemblage was found within these fissures, which consisted of about 2,300 artefacts. The site dates to about 33,000 BC, which means that the site was occupied either by modern humans or late Neanderthals or both. Fieldwork in 2007/08 revealed further material.

Black Rock, Brighton: Ancient Sea Cliff
OS Grid Ref: TQ 336 033
The sea cliffs at Black Rock are a modern cliff line, but there are remains of the Palaeolithic shoreline, which dates to about 250,000 years. Behind the Asda

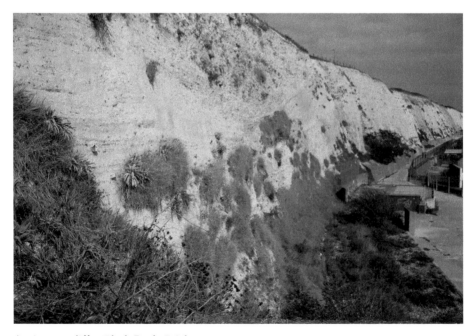

Ancient sea cliff at Black Rock, Brighton.

supermarket, about 5 metres above the Undercliff Walk, the old Brighton Raised Beach can be seen at the base of the modern cliff. This is comprised of a sandy material and rounded pebbles. It is one of the most extensive sections of Ice Age geology in northern Europe.

The beach here would have provided a good hunting ground for Old Stone Age folk. A couple of Palaeolithic flint axes were found at Black Rock. One is probably a hand axe made by early Neanderthal hunters in the vicinity some 250,000 years ago. Remains of mammoth, woolly rhinos, horse and bison have been found here. Remains of whales and seashells have been found in the raised beach itself.

Boxgrove: Ancient Sea Cliff
OS Grid Ref: SU 918 087

The Lower Palaeolithic site at Boxgrove is the oldest known site in Sussex, which dates to 500,000 BC. Excavations during the 1980s and 1990s at Eartham Quarry uncovered waste flakes, hand axes and a piece of human tibia. This area would have been a barren landscape devoid of trees. Woolly mammoths roamed the area.

The waste flakes show where these hunter-gatherers made flint tools. The finding of a piece of human remains here in 1993 meant that this is the oldest human in Britain and is called 'Boxgrove Man'. This is the extinct Homo hidelbergensis. Other hominid remains were discovered in 1996. Boxgrove is the site of a 30-metre raised beach where the West Sussex shoreline existed 500,000 years ago.

Palaeolithic site 500,000 BC at Eartham Pit, Boxgrove.

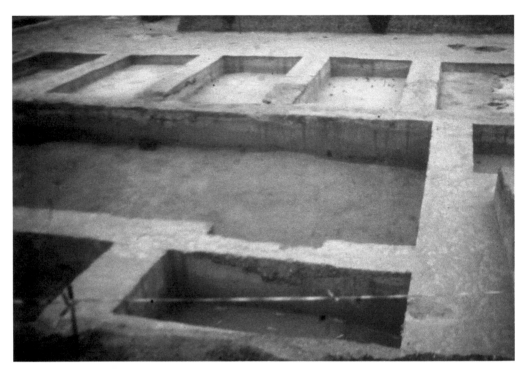

Boxgrove. Excavations at Eartham Quarry.

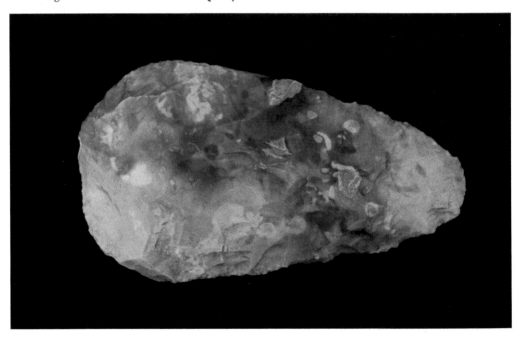

Palaeolithic hand axe, about 400,000 years old, found somewhere in Sussex. Location unknown. (Courtesy of Worthing Museum and Art Gallery)

Slindon: Ancient Sea Cliff

OS Grid Ref: SU 952 081

A sea cliff existed in the area of Slindon some 500,000 years ago and is the same coastline as that at Boxgrove. A raised beach at Slindon has been identified by geological evidence that it was part of a large bay, which ran from Arundel to Chichester. This is now a dry valley. Sand and gravel deposits like beach pebbles can be found here. The area is about 70 metres above sea level. Excavations over the years have revealed Palaeolithic activity in the area some 100,000 years ago in the finding of flint tools. The raised beach can be seen in Park Wood.

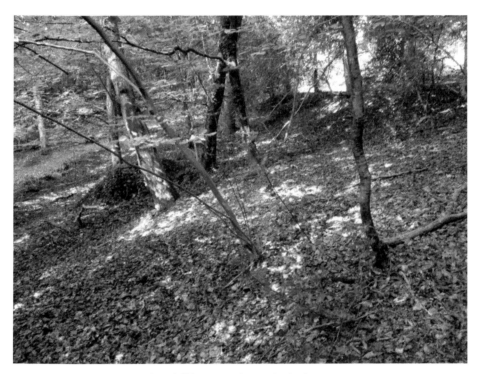

Remains of the old Palaeolithic cliff line in Park Wood, Slindon.

MESOLITHIC

Angmering: Flint-knapping Site
OS Grid Ref: TQ 057 050
A great scatter of lithic artefacts was discovered in Angmering during field walking in 1991 and 1992. The site is situated in a field to the south of the Angmering Decoy. Some 209 worked flints were found, ranging from cores, scrapers, microliths and flakes. The site is probably a flint-knapping one rather than a settlement. To the east is a stream, which would have been an important water source for the Mesolithic folk who lived and worked here.

A flint-knapping site in a field, Angmering.

East and West Hills, Pyecombe: Mesolithic Site
OS Grid Ref: TQ 279 116
A Mesolithic site was found on East and West Hills to the south of Pyecombe. A number of flint artefacts have been found on these hills over a period of several years. A field-walking project and excavations were carried out between 1985 and 1994, covering an area of a 1 square kilometre. Finds included cores, blades, microliths and flakes. Stone tools from the Neolithic and Bronze Age periods were also found on the site. A mutilated Bronze Age barrow exists on the site by the South Downs Way.

Fulking: Flint-knapping Site
OS Grid Ref: TQ 249 125
A large number of Mesolithic flint tools were found by E. Curwen in the area of Brook House, west of Clappers Lane. This is situated in a field to the north of Fulking. Other Mesolithic finds in the area were found to the west at Perching Sands and Tottington Sands. It was probably a flint-knapping site. The stream in the area would have provided water and shelter for the Mesolithic folk who gathered and hunted here.

Great Upon Little, West Hoathly: Rock Shelter
OS Grid Ref: TQ 348 321
There are a group of rock outcrops at Great Upon Little, west of Philpots Farm, which are now mainly tree covered. These are rock shelters used by Mesolithic folk. An excavation by I. C. Hannah in 1931 found a number of worked flints and implements. Some of these were knives and planes, plus a possible barb. The shelters were underneath the overhanging rocks, and the floors were sandy. The site is beneath an Iron Age fort at Philpots.

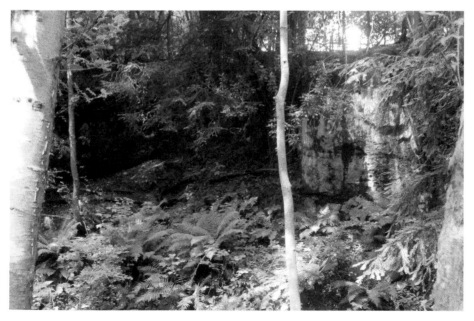

Rock shelter site at Big Upon Little, West Hoathly.

High Hurstwood: Rock Shelter Site
OS Grid Ref: TQ 496 251
In the grounds of the Hermitage at High Hurstwood is a Late Mesolithic rock shelter site dating to about 5000 BC. The Mesolithic people probably used these rock shelters as well. In the past a great number of microliths, micro-cores, blades and flakes have been discovered here. In June 1974, a trial excavation took place here and 2,500 artefacts were found, which included fifty microliths dating to the Late Mesolithic period.

High Rocks: Rock Shelter Site
OS Grid Ref: TQ 561 382
The prehistoric rock shelters at High Rocks, near Tunbridge Wells, were used by the Mesolithic hunter-gatherers. It stands on the top of a hill with a rocky promontory to the north-west. Excavations were carried out on the site where

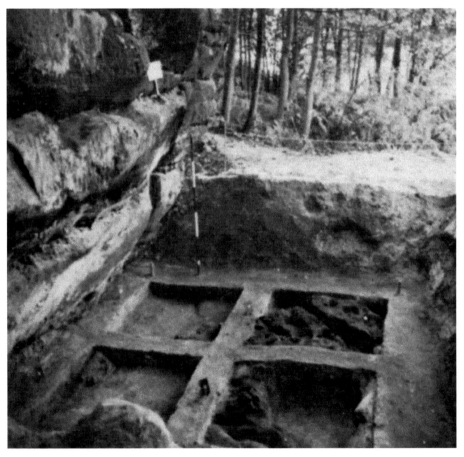

Excavations at High Rocks. (SAC Vol. 98 (1960), plate iii; courtesy of Sussex Archaeological Society)

artefacts have been found such as flint implements, waste material, hearths and charcoal. Evidence of Neolithic activity has also been discovered at the High Rock rock shelters where arrowheads and pottery were found.

Iping Common: Flint Industry
OS Grid Ref: SU 848 222
The Mesolithic site on Iping Common is one of the finest in Sussex. It was found by O. Knowles and dates from about 6000 BC. The site consists of a circular area some 8 metres in diameter. It is situated on undulating Lower Greensand by the edge of a marsh, which extends to a spring and a pond. The West Sussex Excavation Group carried out an excavation of the site in 1960/61. A flint industry consisting of cores, tools and waste flakes were discovered.

Pulpit Rock, Handcross: Ancient Village or Settlement
OS Grid Ref: TQ 273 629
Archaeologists have discovered human occupation going back 8,000 years at a group of sandstone rock outcrops called 'Pulpit Rocks' at Nymans near Handcross. Pieces of flint were found here, which came from the working of

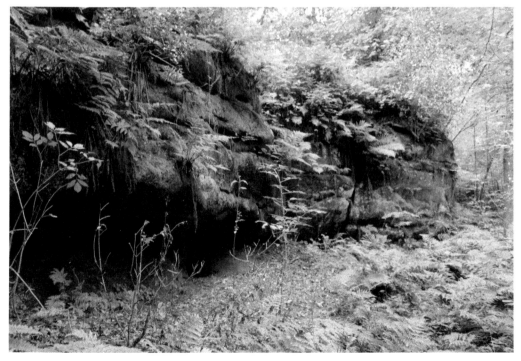

Sandstone outcrops at Pulpit Rock, Handcross, where Mesolithic hunter-gatherers lived and worked.

tools by Mesolithic folk who worked and lived here. The site is either a village or settlement. This area is also a Site of Special Scientific Interest (SSSI).

Rackham: Early Mesolithic Site
OS Grid Ref: TQ 048 147
This early site is situated on Sparrite Farm, north of Rackham. Mr and Mrs Holden located this site during the clearance of woodland in the 1970s. An excavation took place and an assemblage of cores, blades, scrapers, microliths, debitage and rough waste were found. The flint was of good quality and dark grey in colour.

Rock Common, Washington: Flint Assemblage
OS Grid Ref: TQ 130 139
A Middle to Late Mesolithic site was found at Rock Common, north of Washington, in an area known as 'The Rough'. It is situated north of the South Downs on the greensand. An excavation was carried out in 1995 and a concentration of flintwork was found. The Mesolithic assemblage comprised of more than 50,000 flints, which included microliths and knapping waste. A few Neolithic flints were also found on the site. Six 1-square-metre tests pits were dug and artefacts and knapping waste were found.

Site of flint assemblage at Rock Common, Washington.

Mesolithic pit dwelling site at Selmeston.

Selmeston: Pit Dwelling Site
OS Grid Ref: TQ 510 068
Selmeston is probably the most important of the Mesolithic sites in Sussex. Its discovery was identified by quantities of flint implements found in the field south-east of the church during the working of a sandpit. A number of dwelling pits exist on the site, and Professor Clark excavated two of them in 1933. One of the pits yielded more than 6,400 flints, which included worked flints, cores and flakes. A great number of pot boilers were also found. The site is now mainly covered by woodland.

Stone Rocks, East Grinstead: Rock Shelter
OS Grid Ref: TQ 381 347
Stone Rocks are a group of rock outcrops in the Weald. These provided shelter for Mesolithic hunter-gatherers where they lived and worked. A vast number of flintwork was found here, which were eroding from the sandy area at the base of the outcrops. Neolithic flintwork was also found here, which shows that New Stone Age people also used them. The latter would have cleared forests and farmed the land in the area.

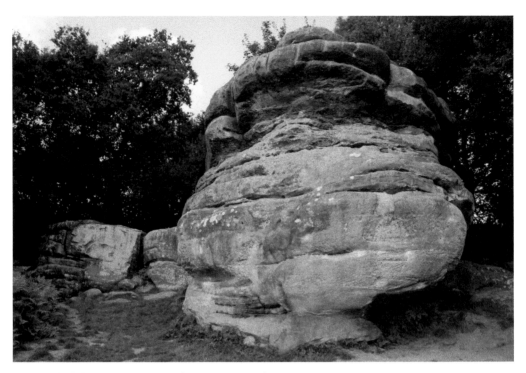

Rock shelter site at Stone Rocks, East Grinstead.

Stonepound, Hassocks: Microlithic Industry
OS Grid Ref: TQ 297 155

H. S. Toms discovered a microlithic industry in the Stonepound sandpit west of Hassocks. The site is situated south of Hurst Road and east of the Brighton Road. He found a pit (possibly a dwelling pit), which was 2 metres in width and about a metre in depth. The pit contained seventy microliths, a few scrapers, thirty cores, some 2,000 flakes and other implements. The sandpit is now filled in and houses have been built in the vicinity.

Streat Lane, Streat: Mesolithic Site
OS Grid Ref: TQ 352 144

A Mesolithic site existed in Streat, which was situated in a field east of Streat Lane and close to a couple of streams. An excavation uncovered a great number of flint artefacts. These were hammers, blades, bladelets, flakes and microliths. The material to make these flint tools either derived from the local head deposit or it was brought here from the South Downs.

Tilgate Wood Rocks, Balcombe: Mesolithic Remains
OS Grid Ref: TQ 330 309 – 330 313

Michael Holland excavated this site east of Balcombe between 1932 and 1934. More than 800 flints and charcoal were discovered here and their depths varied

between a few centimetres and about a metre below the surface. Included in the finds were some cores and core dressings. The rock outcrop is about 7 metres high. The Lower Tunbridge Wells Sand in this area is exposed in a way that made the rocks suitable for shelter to the Mesolithic folk.

West Heath, Harting: Microlithic Flaking
OS Grid Ref: SU 781 225
A microlithic flaking site was discovered on West Heath dating from 10,000 BC to 5000 BC. Its site is above the contour just a few metres from the highest point of the ridge. The River Rother is to the north of the ridge and a few small streams to the south. The area was a suitable site for the Mesolithic hunter-gatherers to work. A number of microliths from the site have been collected by people over the years. Excavations on the site have revealed a vast number of flint tools.

West Hill, Hastings: Settlement
OS Grid Ref: TQ 825 095
An important Mesolithic settlement existed on West Hill in Hastings. The site is situated at the Norman castle and Ladies Parlour. Due to cliff erosion, the southern end of the Norman castle is lost and possibly some of the Mesolithic site as well. The area of Hastings was a vast forest and very populated in Mesolithic times. When the Hastings to Bexhill link road was being built, about 500,000 worked flints were discovered.

NEOLITHIC

Barkhale, Bignor Hill: Causewayed Enclosure and Bronze Age Barrows

OS Grid Ref: SU 976 126

The Neolithic camp at Barkhale is one of the largest causewayed enclosures and was probably constructed as a meeting place for rituals and/or a market. It is oval in shape and consists of about a dozen segments of ditch, which are accompanied by a bank. The site has been heavily ploughed over the decades. The northern section is in a field under pasture and the southern section is in woodland. The camp is bisected by a footpath between the field and woodland.

Excavations were carried out on the site during the twentieth century, which revealed an area of burnt flints and sherds of pottery dating from the Neolithic, Bronze Age, Iron Age and Roman periods. Just north of the causewayed camp are two Bronze Age barrows, which date between 1800 and 1600 BC. These barrows are quite low due to ploughing. One was examined in the 1970s.

Neolithic causewayed enclosure and Bronze Age barrows, Barkhale.

Beacon Hill, Rottingdean. Remains of Neolithic long barrow.

Beacon Hill, Rottingdean: Long Barrows
OS Grid Ref: TQ 363 027

On Beacon Hill, north-west of Rottingdean Windmill, are two Neolithic long barrows known as Beacon Hill I and Beacon Hill II. They date from between 3400 and 2400 BC. The northern one (Beacon Hill I) is very mutilated. Turner described it as a 'long tumulus' in 1863. The southern one (Beacon Hill II) is even more mutilated; the area was once levelled for a golf course, but this no longer exists here. These long barrows are unusual in being so close together.

Bevis' Thumb, Compton: Long Barrow
OS Grid Ref: SU 789 145

The long barrow at Bevis' Thumb is today a grassy mound with flanking ditches. It is one of the largest in south-eastern England and dates to between 2700 and 2500 BC. It is 70 metres in length and 16 metres on the west side, but only 9 metres on its eastern side due to the road having truncated it. A limited excavation took place in 1980 by P. Drewett where fragments of bone and flint flakes were found.

Bevis was a legendary local giant and it is said that he crossed from the Isle of Wight to Southampton in one stride. Legend says he fed himself on a whole ox a week, which was washed down by two hogsheads of ale – one hogshead is 75 gallons. Bevis is more often linked to Arundel and it is said that the town was named after his horse 'Hirondelle'.

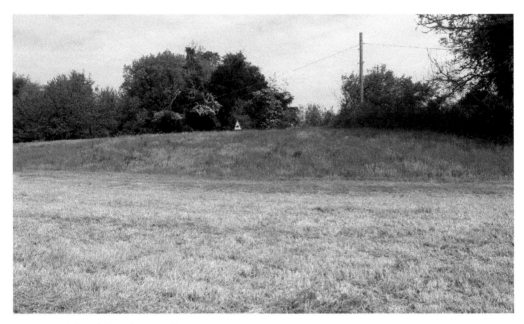

Bevis' Thumb long barrow, Compton.

Blackpatch, Patching: Flint Mines
OS Grid Ref: TQ 094 088

The Neolithic flint mines at Blackpatch are situated on the southern part of the hill, about 800 metres south of the summit. There are approximately 100 mine shafts, which are between 1 and 3 metres in depth. They are connected with galleries, which are some 8.5 metres in length. The shafts were

Site of Neolithic flint mines at Blackpatch.

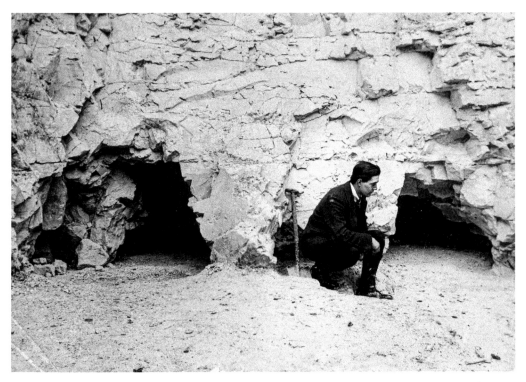

Excavations of the Blackpatch flint mines in 1922. John Pull is in one of the mine shafts. (Courtesy of Worthing Museum and Art Gallery)

ploughed out in the 1950s, leaving just a few remaining, which are visible as slight depressions about 0.25 metres in depth. Some shallow spoil heaps can also be seen on the site.

The flint mines were excavated by John Pull between 1922 and 1932. He excavated seven shafts where flint flakes, human remains, deer antlers and pottery were found. The finds were determined by radiocarbon as dating to between 3290 BC and 3000 BC. Nearby is the site of some temporary huts, which may either be a settlement or temporary hut sites associated with the flint mines. In 2005 Channel 4's *Time Team* crew excavated there with the help of the Worthing Archaeological Society.

Bury Hill, Houghton: Causewayed Enclosure
OS Grid Ref: TQ 001 121
This ovoid enclosure is situated on the summit of the hill. It dates from the Early Neolithic period. It measures 124 metres south-west to north-east and 120 metres north-west to south-east. Excavations of the site in 1979 revealed that the ditch was continuous with an entrance at its western end. Neolithic flints, animal bones, fragments of human bone and sherds of pottery were found on the site. The enclosure exists today as a slight earthwork in a field just north of the South Downs Way.

Bury Hill
causewayed
enclosure.

Butts Brow, Willingdon: Causewayed Enclosure
OS Grid Ref: TQ 579 017

The causewayed enclosure at Butts Brow dates from between 4000 to 3000 BC. It is situated just north of a car park and comprises of a ditch and bank. Eastbourne Heritage carried out excavations over a few years, starting in 2016. These excavations showed that the enclosure did not seem to have been a defensive earthwork or that any settlement was evident. It was probably built for more esoteric purposes. Flint tools and pottery were found on the site. There are some Bronze Age tumuli in the vicinity.

Camel's Humps, Cliffe Hill: Long Barrow
OS Grid Ref: TQ 431 110

This long barrow is situated on Lewes Golf Course on Cliffe Hill to the east of Lewes. It is on a south-east to north-west alignment and is 32 metres in length, 18 metres in

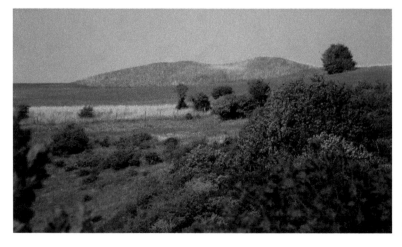

Camel's Humps,
Neolithic long
barrow, Cliffe
Hill, Lewes.

width and 3 metres in height. The long barrow is surrounded by a ditch. The name refers to the fact that the centre of the barrow has collapsed, giving it the appearance of two humps. The long barrow can be seen from the town in Lewes.

Church Hill, Findon: Flint Mines
OS Grid Ref: TQ 114 083

The Neolithic flint mines at Church Hill are the earliest flint mines in Britain, dating to around 4600 BC. They are situated on top of the hill about 320 metres south-west of Findon's church. There are thirty-six known mine shafts on the hill, but these have been ploughed out. Little can be seen on the site today, but vague humps may represent spoil heaps, which are now mainly levelled by ploughing.

The flint mines were excavated by Ernest Willet in the 1860s and John Pull between 1932 and 1952. One of the finds was a large tree-felling axe, which is on display in Worthing Museum and Art Gallery. The finding of Bronze Age pottery in some of the shafts suggest that they were also used in this period. The author noticed other possible shafts on the hill and found a flint axe on the site.

Above: Church Hill, Findon. Site of the flint mines showing crop marks.

Right: Neolithic tree-felling axe found in the flint mines at Church Hill, Findon. (Courtesy of Worthing Museum and Art Gallery)

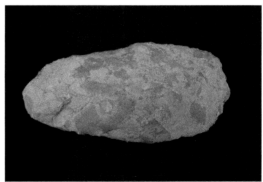

Cissbury: Flint Mines
OS Grid Ref: TQ 139 080

Cissbury, north of Worthing, is the site of a Neolithic flint mine complex, which date from about 4350 BC. The site comprises of about 270 shafts, which are situated on the south-western side of the hill, intersected by the Iron Age hillfort. The shafts are visible as depressions with mounds, which are the spoil heaps from when the mines were dug. They are next to Grimes Graves in Norfolk, the best known of the British flint mines.

The Cissbury flint mines have been excavated on a number of occasions, notably by General Pitt Rivers (then known as Lane Fox) in 1867–68 and 1875, and John Pull between 1952 and 1955. Many artefacts were found, such as axes, shoulder blades, deer antlers and a few skeletons. One of the skeletons was a crouched burial found in 1878 with chalk and flint blocks surrounding it. There was a flint axe with the burial. Some carvings were discovered in one of the shafts: a red deer, bull with horns and a bird.

Depressions representing Neolithic flint mines, Cissbury.

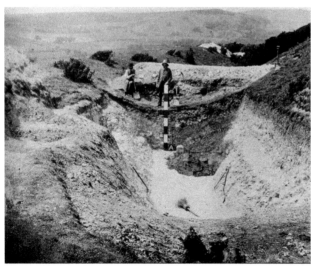

Excavations of the flint mines at Cissbury in 1875. (Courtesy of Worthing Museum and Art Gallery)

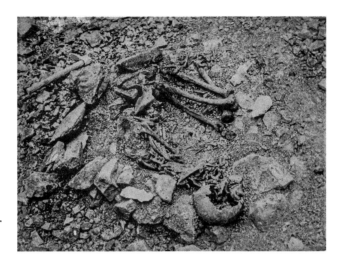

Crouched burial surrounded by chalk and flint blocks and a flint axe found at Cissbury in 1878. (Courtesy of Worthing Museum and Art Gallery)

Cockroost Hill, Portslade: Possible Causewayed Enclosure
OS Grid Ref: TQ 246 085

A linear circular enclosure exists on Cockroost Hill. An aerial survey was conducted in 1989 and a large enclosure was detected on the eastern side of the hill. This enclosure seemed to have a large number of causeways within the rampart circuit, which may be Early Neolithic in date. This may have been a causewayed enclosure. There are prehistoric and Romano-British field systems on this hill. Flintwork and Late Bronze Age and Early Iron Age pottery was found at Cockroost Bottom during excavations.

Site of a Neolithic enclosure circuit on Cockroost Hill, Portslade.

Causewayed enclosure on Combe Hill, Jevington.

Combe Hill, Jevington: Causewayed Enclosure
OS Grid Ref: TQ 576 022

The Neolithic causewayed enclosure on Combe Hill dates from about 3200 BC. It contains two concentric ditches, banks and causeways. The banks are about 0.8 metres in height and the ditches have a depth of about 0.5 metres. The northern section of the monument is interrupted by the scarp slope of the South Downs. There are two causeways on the eastern and southern sides, which may have been the original entrances to the enclosure. A few Bronze Age barrows exist near the enclosure.

A small excavation on the site in 1949 confirmed its Neolithic nature by the discovery of flint tools, pottery and animal bone, which included fragments of ox bone. Another excavation took place in 1994. Flintwork was found in both excavations and in one of the trenches, and evidence of flint knapping was found. Of all the flint tools, the most interesting of them was the discovery of three polished axes.

Court Hill, East Dean: Enclosure Systems
OS Grid Ref: SU 898 138

On Court Hill are the remains of two Early Neolithic enclosure systems dating to the third millennium BC. These were first noted by E. Holden in the 1950s. The southern one is almost square shaped and is 170 metres in diameter and consists of a bank and ditch. The northern one is crescent shaped and may have only been partly built and abandoned. Excavations were carried out in the 1980s where flint flakes, Neolithic pottery and animal bone were found.

Flint Heap, Stanmer: Neolithic Activity
OS Grid Ref: TQ 329 105

Flint Heap is situated on the downland to the north-west of Stanmer village. This is an area where Neolithic activity occurred. A vast quantity of flint implements and flakes were found on the site. These tools consisted of axes, scrapers and blades. It is thought that these tools were made to clear the woodland on the downland slopes in the area for agricultural purposes. They would have made tools for preparing animals for food as well. They probably had a settlement in the area.

Halnaker: Enclosure
OS Grid Ref: SU 921 097

The enclosure on Halnaker Hill is oval shaped and measures 175 × 145 metres. It dates from the Early Neolithic period and comprised of a bank and ditch. Due to much ploughing the site exists today as a slight earthwork. During excavations between 1981 and 1983 worked flints and Neolithic pottery were found. Within the enclosure is Halnaker Windmill (a brick tower mill) dating to 1740. East of the mill is a slight mound, which is the site of an earlier windmill of 1540. It is thought that a windmill on this site goes back to 1340.

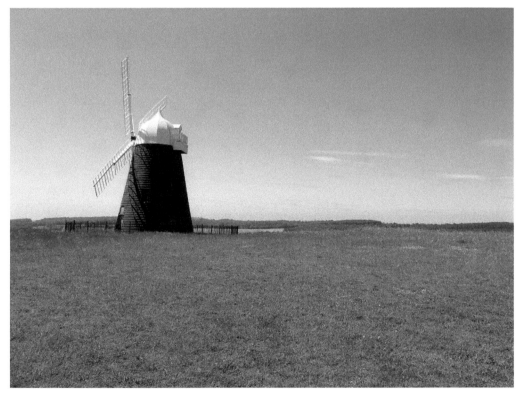

Site of a Neolithic settlement, Halnaker.

Harrow Hill: Flint Mines
OS Grid Ref: TQ 081 100

The Neolithic flint mines on Harrow Hill are situated on the north-eastern slope of the hill. There are about 160 shafts, which are visible as depressions together with spoil heaps. The mines were in operation between 4000 and 2200 BC. These flint mines have shafts up to 3 metres deep and are connected with galleries. There is a model of a shaft of the Harrow Hill flint mines in Worthing Museum and Art Gallery.

These flint mines have been excavated by archaeologists over the past 125 years: Collyer in 1896, Curwen and his son in 1924–25, Hallman in 1936 and Felder, Sieveking and Holgate in the 1980s. Shoulder blades and antlers as well as axes were discovered during these excavations. A chalk block was found on a wall of a shaft with graffiti on it, which may represent a field system.

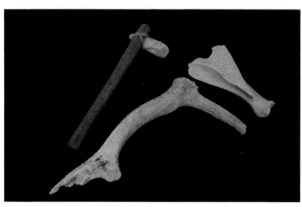

Above: Depressions representing the remains of flint mines, Harrow Hill.

Left: Shoulder blade, antler and flint axe found in the flint mines at Harrow Hill. (Courtesy of Worthing Museum and Art Gallery)

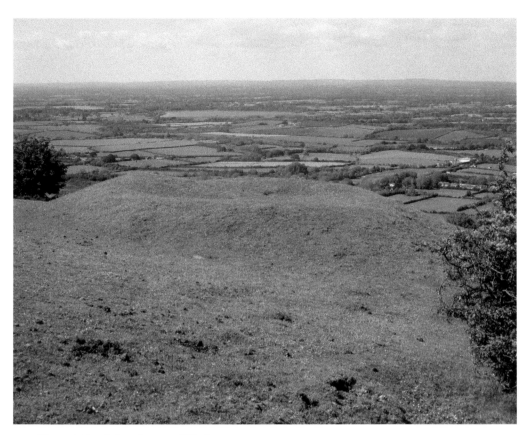

Hunter's Burgh long barrow, Wilmington.

Hunter's Burgh, Wilmington: Long Barrow
OS Grid Ref: TQ 549 036
This long barrow is situated on the slope of the hill, which makes it a prominent feature. It faces north to south and is an elongated earthen mound with flanking ditches where its southern end is broader and higher. It appears to be a circular mound due to an antiquarian having dug it and mutilated it. It is 58 metres in length, 23 metres in width and 2 metres in height. It would have been seen as a monument from the Weald.

Lancing: Neolithic Road
OS Grid Ref: TQ 194 061
The footpath, which leads from the former Sussex Pad Inn towards Cissbury is a Neolithic road dating from 4000 to 2000 BC. It is a branch of the ridgeway from Beachy Head to Cissbury, Chanctonbury and westwards towards Salisbury Plain. This ancient trackway may have been used to transport flint from the flint mines to the Continent. Other produce may have been imported and exported along this route over the centuries.

Route of the Neolithic road in Lancing.

Long Burgh, Alfriston: Long Barrow
OS Grid Ref: TQ 499 033
Long Burgh is one of the longest of the long barrows in Sussex, measuring 56
metres in length, 28 metres in width and 1.8 metres in height. It was once probably

Long Burgh long barrow at Alfriston.

higher than this. The long barrow dates from between 3400 and 2400 BC. It has two flanking ditches that are parallel to the mound. A skeleton and urn were found in the long barrow when a landowner dug into it in 1767, but these finds are now lost.

Long Down, Eartham: Flint Mines
OS Grid Ref: SU 931 093
A flint fine complex is situated on Long Down, which dates from about 4000 BC. There are about fifty mine shafts on the hill and some possible ones further to the north. The shafts exist today as depressions, which are mainly grass covered. Excavations were carried out by Salisbury between 1955 to 1958 and Holgate in 1984. A few shafts were examined and flint implements, deer antlers and sherds of pottery were found in them. Flint-working areas have been discovered around the site.

Neolithic flint mines at Long Down, Eartham.

Neolithic long barrow at Money Burgh, near Piddinghoe.

Money Burgh, Piddinghoe: Long Barrow
OS Grid Ref: TQ 425 037
This long barrow dates from the Early Neolithic period. It is situated on the hill to the west of the minor road from Lewes to Newhaven at Deans, near Piddinghoe. It is on a north-east to north-west alignment and has a length of 38 metres and a width of between 9.5 and 15.5 metres and 2 metres in height. There seems to be no flanking ditches surrounding the long barrow visible today. Money Burgh has been badly affected due to exploration by antiquarians in the past.

Mount Carvey, Cissbury: Neolithic Village
OS Grid Ref: TQ 088 094
A Neolithic village existed on Mount Carvey, which is associated with the flint mines on Cissbury. H Wyatt, who owned land at Mount Carvey in the 1920s, had accumulated a vast quantity of worked flints from the ploughed field. John Pull made a search of the site and traced a prehistoric village and recorded a linear strip of depressions. These were the sites of huts. Two similar Neolithic villages exist nearby at High Salvington and Myrtle Grove, near Patching. They are all associated with the flint mines.

The village consisted of a street, huts, a pond and a communal fire. This village is where people brought flints from the mines to be knapped into tools. They traded with the Continent. The site of the village is situated south of Cissbury and west of a footpath from Broadwater. This footpath is the Offington to Cissbury greenway, an ancient trackway that probably goes back to Neolithic times.

Offham Hill, Lewes: Causewayed Enclosure
OS Grid Ref: TQ 399 117
This was a small enclosure that comprised of two circles and ditches. The enclosure dates from 3550 to 3390 BC. The eastern end was destroyed by the construction of Offham Chalkpit in the nineteenth century. The western end still survives in woodland and in a field. In the case of the latter, ploughing has destroyed most of it. Excavations of the southern side of the enclosure in 1976 showed that it was originally constructed in a woodland clearing and contained elongated pits. A crouched burial, disarticulated human bones, sherds of Neolithic pottery and a polished axe were found.

Paddockhurst Park, Worth: Flintwork Assemblage
OS Grid Ref: TQ 321 331
A Neolithic site existed at Paddockhurst Park. A number of flint artefacts were found in the area by farmers and gamekeepers during the 1970s and 1980s. Some flint implements were also found at nearby Worth Abbey. Of the finds, some were leaf-shaped arrowheads, scrapers, blades, polished axes and debitage. About thirty soft-hammer-struck flints on the site may date from the Mesolithic period.

Stoke Down, West Stoke: Flint Mines
OS Grid Ref: SU 832 096
The Neolithic flint mine complex on Stoke Down is situated just north of Stoke Clump. The complex runs in an east–west direction and there are about twenty; shafts, which are not connected with any galleries. Three of the mine shafts were excavated by Major Wade between 1910 and 1913. Due to ploughing of the site, there are no remains of the flint mines to be seen today.

Stoughton Down: Oval Barrows
OS Grid Ref: SU 822 122
The two oval barrows on Stoughton Down are known as Stoughton I and Stoughton II. They date from the Early to Middle Neolithic period. Stoughton I is 36.6 metres in length and 18 metres in width. Stoughton II is 24.4 metres in length and 12.5 metres in width. Both are only about 1 or 2 metres in height. There are ditches along their sides, but not at their ends. Although in good condition, the long barrows have been mutilated over the years. Stoughton I is the northern one of the two.

Possible long barrow at The Bostle, Woodingdean.

The Bostle, Woodingdean: Possible Long Barrow
OS Grid Ref: TQ 373 530
The Brighton and Hove Archaeological Society conducted a survey in 1996 at The Bostle. Neolithic flint flakes and fire-cracked flint were found on the site. The long barrow faces north to south and appears as a grassy area in the ploughed field. By examining aerial photographs, it has been shown that the feature is more likely to be a robbed long barrow instead of a group of round barrows.

The Giant's Grave, Firle Beacon: Long Barrow
OS Grid Ref: TQ 483 059
This long barrow has a low mound that is surrounded by a shallow ditch. It is situated on the top of the South Downs, west of Firle Beacon. The long barrow is 31 metres long, 12 metres wide and 2.4 metres in height and has been disturbed over the years by either flint extraction or by antiquarians. It is known as 'the Giant's Grave' because it is reputed that a giant who lived in the area was buried here. It is also said that a silver coffin was buried on Firle Beacon.

The Giant's Grave long barrow, Firle Beacon.

The Gumber, Slindon: Oval Barrow
OS Grid Ref: SU 962 125

The oval barrow at The Gumber consisted of a raised area measuring 32 × 20 metres and was visible from aerial photographs. It is situated on the hill north of the Roman road – Stane Street. An excavation on the site revealed a number of struck flakes and cores, but no ditches were found surrounding the oval barrow. A Bronze Age round barrow exists to the east of the oval barrow and to the south are three others. Two of these are twin barrows.

The Trundle, Singleton: Causewayed Enclosure
OS Grid Ref: SU 877 111

At The Trundle, Singleton is a Neolithic causewayed camp situated on St Roche's Hill. This was constructed in about 3300 BC. It comprises of a pair of concentric banks and ditches and had just a single entrance on the north-eastern side. The enclosure was first noticed by aerial photography in 1925. Excavations by E. C. Curwen in 1928 and 1930 revealed a crouched burial of a man, flint implements, a saddle quern and a pit containing the bones of ox and sheep.

The Neolithic enclosure was probably a focal point for the farming communities who gathered here for social and ritual purposes. The site is one of the earliest indications of permanent communal living and agriculture on the South Downs. All that remains of the enclosure today is a low, inner, raised circle within the Iron Age hillfort. The name 'Trundle' means 'ring shaped'.

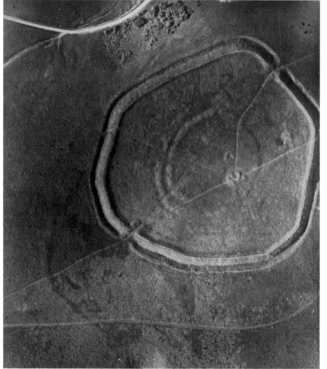

Above: Causewayed enclosure at The Trundle, Singleton.

Left: Aerial view of The Trundle. (Trundle, Curwen 'Sussex Air-Photographs' album 1928; courtesy of Sussex Archaeological Society)

Whitehawk, Brighton: Causewayed Enclosure
OS Grid Ref: TQ 330 048

This enclosure was built on a narrow ridge to the north of the summit. It dates from between 4000 and 3000 BC and is one of Britain's earliest monuments. The site is comprised of four concentric rings, chalk bank and ditch. The outer one is partly absent on the steep east slope. The dimensions of the earthwork are 320 metres north to south and 235 metres from east to west. It was partly destroyed by Brighton Racecourse, which was built in the eighteenth century.

Whitehawk Camp was a marketplace where animals were brought in order to slaughter for food and possibly ceremonial functions. It was also used as a meeting place for tribes who worked nearby for feasting, burials and other activities. The site was partially excavated in the 1920s and 1930s. A vast quantity of Neolithic pottery, flint and bone implements, flint flakes and skeletons were found. Of the skeletons two were of a young woman and her baby.

Causewayed enclosure at Whitehawk, Brighton.

CHALCOLITHIC

Ashcombe Bottom, Lewes: Beaker Occupation
OS Grid Ref: TQ 373 119
The Beaker settlement at Ashcombe Bottom dates from the Neolithic/Bronze Age period. It is situated in a valley west of Lewes. Excavations on the site were carried out and the colluvial deposits in the middle of the valley were 1.5 metres thick. However, they contained a buried soil where there were a series of marks. A number of sherds of Beaker pottery and about twenty-six Beaker vessels were found, which suggests that the site was a settlement and not a funerary monument.

Baily's Hill, Crowlink: Funerary Monument
OS Grid Ref: TV 545 966
A possible Beaker cairn was discovered on Baily's Hill, which was used in the construction of a Bronze Age barrow. This was excavated in the summer of 1998 and a number of cremation pits were found, which represents a phase of Late Neolithic/Early Bronze Age burials on the site. An assemblage of pottery of the period was also discovered. The excavation was carried out prior to the site succumbing to the sea.

Belle Tout, Eastbourne: Beaker Settlement
OS Grid Ref: TV 561 957
This is a small Neolithic/Bronze Age enclosure situated on the cliffs west of Beachy Head. It dates from about 2000 BC and is a Beaker settlement that consists of a bank and ditch. During excavations in 1968/69 remains of a flint cairn, flint-working areas, hearths, a timber long house, carbonised wheat and barley and Beaker pottery were found. It was a mixed farming community. About 3,600 flints on the site date from the Mesolithic period.

The larger, more extensive earthwork is Neolithic in date and is visible today as a bank, which is covered by vegetation in some places. Due to coastal erosion a large part of the settlement has been lost to the sea. Belle Tout Lighthouse was built on the site in the nineteenth century, which was replaced by Beachy Head Lighthouse in 1902. The former is now a homely dwelling.

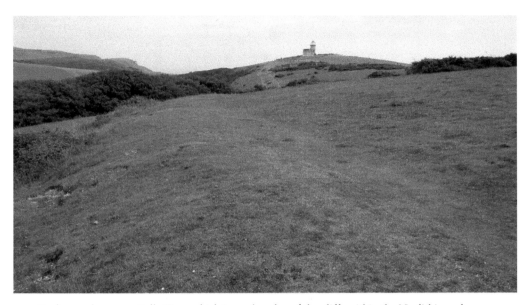

Beaker settlement at Belle Tout, which is on the edge of the cliffs within the Neolithic enclosure, Eastbourne.

Church Hill, Brighton: Possible Stone Circle
OS Grid Ref: TQ 307 044

It is possible that a stone circle once existed on Church Hill in Brighton. There are nineteenth-century accounts that there were large stones surrounding St Nicholas' Church. Nothing remains of these stones today and it is uncertain if the stones formed part of an ancient monument or just a natural deposit of sarsen stones. Decorated beaker urns were found on Church Hill, which suggests that a burial ground of the period existed here. A tumulus known as 'Bunkers Mound' is said to have existed on Church Hill.

Site of possible standing stones at St Nicholas' Church, Brighton.

Remains of the small henge monument at Cock Hill, Patching.

Cock Hill, Patching: Henge Monument
OS Grid Ref: TQ 089 097
This is a small henge monument. It consists of a penannular ditch that dates from
the Late Neolithic and Early Bronze Age periods. The eastern side was levelled by
ploughing. Within it are the remains of a settlement and cremation cemetery of Late
Bronze Age date. Excavations were carried out on the site between 1952 and 1957 and
traces of timber roundhouses, cremation burials and clay loom weights were found.

Cuckoo Bottom, Lewes: Beaker and Early Bronze Age Activity
OS Grid Ref: TQ 388 109
Cuckoo Bottom is the site of Beaker and an Early Bronze Age activity. There is also a
possible Beaker valley entrenchment on the site as well. The site was investigated after
trees and shrubs were uprooted during the Great Hurricane of 16 October 1987.
Prehistoric features and colluviam were found. Sherds of pottery dating to the Beaker
and Early Bronze Age periods were recovered from the colluviam and also from a
ditch. The latter is believed to be part of the valley entrenchment. Cuckoo Bottom
seems to be a Beaker occupation site similar to the one at nearby Ashcombe Bottom.

Goldstone, Hove: Sarsen Stone Circle
OS Grid Ref: TQ 290 059
In Hove Park there is a large stone surrounded by much smaller ones. These
stones are not in their original position. The large stone once stood further south
and the smaller ones to the north. At the beginning of the nineteenth century, the
Goldstone was thought to be a sacred stone of the Druids. This made many people

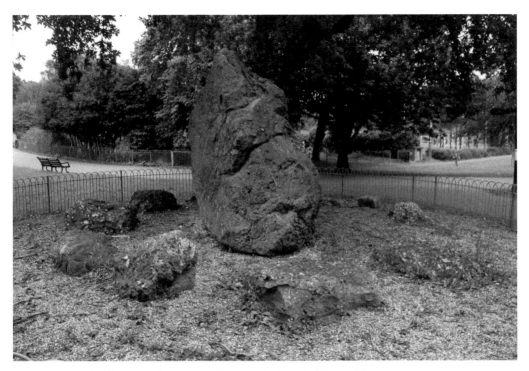

Stones said to have once been part of a stone circle at Goldstone, Hove.

visit it, damaging crops in the process, which made the landowner bury it. The smaller stones were buried in a pond.

The large stone was brought to the surface in 1900 and erected in its present position. The smaller stones were exhumed in 1906 and placed around the large one in a circle. It is possible that these stones represented an ancient stone circle dating to the Late Neolithic/Early Bronze Age in the area.

Lavant Henge, East Lavant: Henge Monument
OS Grid Ref: SU 966 094
This henge monument dates from the Late Neolithic/Early Bronze Age period. It is situated just west of Chalkpit Lane, north of East Lavant. The site was excavated by Southern Archaeology in 1997 and a complex of concentric ditches were found. A large number of red deer antlers were discovered on the outer ditch, which suggests that the site may have been used as a red deer cult. These excavations were carried out prior to the building of a water pipeline, which connected reservoirs to facilities at Slindon and Funtington.

Playden: Timber Circle
OS Grid Ref: TQ 921 226
The timber circle at Playden, north of Rye, dates from the Late Neolithic/Early Bronze Age period. It is a horse shaped setting of timbers, which was later replaced

by a circular mound built with white sand. The present earthwork has a ring ditch and also a ditch, which runs in a north-east to south-west alignment. The site was excavated between 1929 and 1931. Postholes, stake holes and probable stone holes were found within the enclosure, which may represent a wattle-and-daub fence. A number of flints were found in the enclosure.

Pyecombe: Beaker Bowl Barrow
OS Grid Ref: TQ 283 118
The Beaker bowl barrow at Pyecombe dates from the Late Neolithic/Early Bronze Age period. It consisted of a penannular ditch with internal postholes. The latter may indicate a possible timber circle. The barrow is now ploughed out. The site was excavated in the autumn of 1988 where many sherds of pottery were found. A crouched burial was discovered in a pit in the centre of the ditch, which had a wristband and a copper dagger. One pit contained struck and burnt flints and the remains of a beaker. The site is just east of the Mesolithic site at East and West Hills.

Round Hill, Steyning: Cairn Structure
OS Grid Ref: TQ 167 099
A Late Neolithic or Early Bronze Age feature existed on Steyning Round Hill. This seems to have been a cairn made from flint. The flints (many were burnt) that made up the cairn were large and formed a circle about 12 metres in diameter. The flints were later removed and probably reused in later buildings. Where there is a cairn it usually means that a cist was put inside and so one probably still exists here. Nothing remains above ground today.

BRONZE AGE

Barpham Hill, Wepham: Cross-ridge Dyke
OS Grid Ref: TQ 067 096

The cross-ridge dyke on Barpham Hill is aligned east to west and is about 246 metres in length. It has a ditch roughly 9 metres wide and about 1.2 metres deep. The monument has a bank on its southern side, which is about 6 metres wide and 1.5 metres in height. The western end has been partly damaged by ploughing. It dates from the Middle Bronze Age period.

The purpose of these dykes – also known as a cross dyke, spur dyke, linear ditch, linear earthwork or covered ways – are not known. They could be either defences, a land boundary, territorial limits or cattle droveways. It is possible that they were built so that people could move their animals along trackways without being seen. Some covered ways may have been made accidentally due to the passage of people and animals who broke up the surface and wore the path down to the chalk.

Earthworks of the cross-ridge dyke on Barpham Hill, Wepham.

Bronze Age barrows and linear earthwork on Bignor Hill. The latter is marked by the tree line in the distance.

Bignor Hill, Bignor: Linear Earthwork and Barrows
OS Grid Ref: SU 968 131
The linear boundary earthwork on Bignor Hill runs in a north-west to south-east alignment and is about 500 metres in length. It consists of a bank and ditch. A partial excavation of the site in 1915 revealed fragments of a funerary urn dating to the Bronze Age and sherds of Roman pottery. The earthworks conclude at the southern end, but it is possible that it did continue further south where a footpath may mark it. The northern end curves slightly to the east and joins a footpath. The earthwork is mainly tree lined.

At the northern end of the earthwork are some Bronze Age bowl barrows. The western barrow is indicated by a mound, which is 12 metres in diameter and 1 metre in height. The eastern barrow is also represented by a mound some 18 metres in diameter with a height of 1 metre. Both barrows have a hollow at their centre, which suggests an excavation by antiquarians. It is recorded that during this excavation a cremated bone and funerary urn fragments were found in one of the barrows.

Blackcap Hill, Lewes: Barrows
OS Grid Ref: TQ 375 127
There are about twelve barrows on Blackcap Hill. The southern one is the largest of them, which has a diameter of 8.6 metres and 0.45 metres in height. It is surrounded by a ditch. There is a hollow at the top of the mound

Bronze Age barrow on Blackcap Hill, near Lewes.

suggesting that an excavation was carried out in the past. There was once a windmill at Blackcap and the name may have derived from the colour of the mill's cap.

Black Patch, Alciston: Settlement
OS Grid Ref: TQ 498 040
The Middle and Late Bronze Age settlement at Black Patch was discovered by G. A. Holleyman. The site comprises of a series of hut platforms, enclosures and lynchets. The lynchets are situated on a spur of the South Downs and include two double-lynchet roads and a hollow way. Some of the enclosures are round and single, but some are double and incomplete. The huts have central hearths.

Cissbury, Findon: Barrows
OS Grid Ref: TQ 134 078
There are three barrows on Cissbury and are situated on the hill outside of the Iron Age hillfort. One of these is west of the hillfort, there is another to the south on Vineyard Hill and another to the east. They are much reduced due to the plough and the western one being the most prominent of the three, which has a hollow in its centre. In the nineteenth century W. Greenwell found two Early Bronze Age beakers together with an inhumation in one of the barrows. However, it is not recorded from which one.

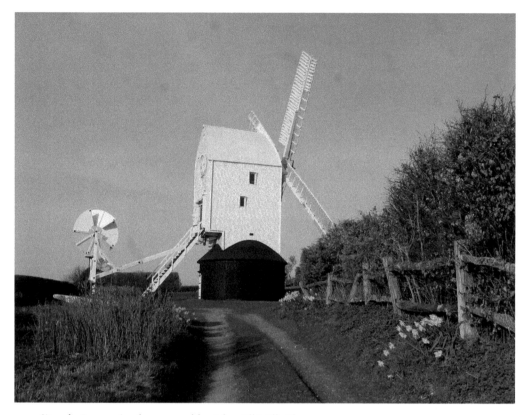

Site of a Bronze Age barrow and burial at Jill Mill, Clayton.

Clayton Hill, Clayton: Windmill Barrow
OS Grid Ref: TQ 303 134
An Early Bronze Age barrow existed on Clayton Hill, which was excavated in 1805. The barrow was composed of burnt stone and charcoal where animal bones were found, and an incensed cup was found in the centre. These finds were not recorded in detail. A cremation urn containing a pendant was discovered on the site in 1806, described as 'too broken for preservation'. Jill Windmill (of Jack and Jill Windmills fame) now stands on the site of the barrow.

Devil's Humps, Stoughton: Round Barrows
OS Grid Ref: SU 821 112
Devil's Humps is sometimes known as 'King's Graves'. The four round and bell barrows are situated on a ridgeway and form a cemetery group. They are some of the most impressive barrows that survive in the district, and two of them really stand out well. The site consists of two bell barrows and two bowl barrows. It is possible that there were others forming a line. During excavations in the nineteenth century, burnt bones, an antler, horse's tooth and Iron Age pottery were found.

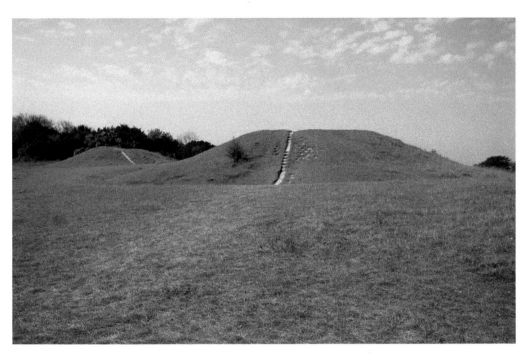

Bell barrows at the Devil's Humps.

Devil's Jumps, Hooksway: Barrow Cemetery
OS Grid Ref: SU 824 173
The group of five large bell barrows at Devil's Jumps are the most impressive and the best-preserved barrows on the South Downs in Sussex. They all have a surrounding ditch. There are traces of two other smaller barrows. It is a barrow cemetery dating between 1800 and 1600 BC. The barrows are aligned south-east to north-west – with the sunset at the summer solstice. In 1853, excavations found some cremated bones in two of the large barrows, but nothing in the smaller ones.

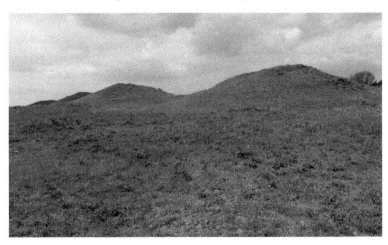

Group of large bell barrows at the Devil's Jumps, Hooksway.

Earthworks in the agricultural site at Ewe Bottom, Patcham.

Ewe Bottom, Patcham: Bronze Age Agricultural Site
OS Grid Ref: TQ 307 098
There are earthworks in the form of lynchets in fields at Ewe Bottom, north of Patcham, which represent the site of a Bronze Age farming community. It is not known what the purpose of these earthworks were. The northern end has good earthworks, but those at the southern end are not very discernible due to ploughing. To the north of the earthworks is an entrenchment, which is represented by a mound with ditches.

Firle Beacon: Barrow Cemetery
OS Grid Ref: TQ 485 059
There are three bowl barrows on Firle Beacon, which date from 1800 to 1500 BC. They are situated on the summit of the South Downs. The largest one is 23 metres in diameter and 1.5 metres in height. Firle Beacon was opened in 1820 and the pits can be seen today. Two cinerary urns, a bronze pit, barbed arrowhead and an inhumation were found. This barrow was used as a beacon during the Napoleonic Wars. The smaller barrows are situated to the south and south-east.

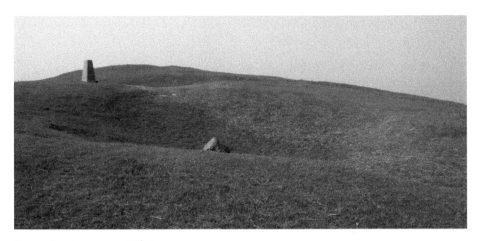

Bronze Age barrow on Firle Beacon.

Fitzall Heath, Iping: Barrow Cemetery
OS Grid Ref: SU 849 215
The barrow cemetery on Fitzall Heath consists of eight barrows running in an east to west alignment. The eastern ones are closely spaced, but the western ones are more dispersed. The barrows exist today as mounds, which range from 12 to 26 metres in diameter and 0.25 to 2.5 metres in height. One of the barrows has a hollow in the centre, suggesting that it had a partial excavation. These barrows are covered in bracken and heather. Close by is the line of a Roman road, which exists here as an earthwork.

Five Lords Burgh: Tumulus
OS Grid Ref: TQ 487 037
This barrow is situated on the South Downs north of Seaford, adjacent to a Roman road. It is thought that the name is either derived from the graves of lords

The tumulus at Five Lord's Burgh.

that were buried here or that five manors met here. The name 'Burgh' is from the Old English *beorg* meaning 'mound' or 'tumulus'.

Friday's Church, Barpham Hill: Bronze Age Barrows
OS Grid Ref: TQ 066 098
Friday's Church is a group of a few Bronze Age barrows. Excavations were carried out at two of them in the 1960s and 1970s, where flintwork, Bronze Age pottery, Romano-British pottery, Roman coins and cremations were found. One of the barrows had an incomplete ring ditch. These barrows have been destroyed by the plough.

The origin of the name Friday's Church is obscure. According to a shepherd it was so named because the Romans had a temple here. Another suggestion is that the name came from the Old Welsh *cruc* meaning 'hill', 'barrow' or 'mound'. Another possibility is that it was named after Queen Fridias or Freya, who is reputed to have been buried here.

Harrow Hill: Enclosure
OS Grid Ref: TQ 081 101
Next to the Neolithic flint mines on Harrow Hill is an enclosure or hillfort dating to the Late Bronze Age period. It comprises of a single ditch and bank, which is almost square in shape with the south-eastern corner being rounded. It has two entrances on its western and north-eastern sides. Excavations by Holleyman in 1937 revealed pottery and teeth of an ox, sheep and pig. The postholes on the site may be those of a pre-rampart palisade enclosure.

Harting Down, South Harting: Multiple Cross Dykes
OS Grid Ref: SU 797 184
A multiple cross-dyke system exists on Harting Down, which was constructed across a chalk ridge. The site is aligned north to south and there are four parallel ditches. The eastern one is the largest at about 6 metres in width and about 0.5 metres in depth. All but one of the ditches are flanked on their eastern side, which are 5 metres in width and 1 metre in height.

Heyshott: Barrow Cemetery
OS Grid Ref: SU 907 165
The barrow cemetery on Heyshott Down is situated by the South Downs Way. It is one of the best in the county. There are ten round barrows, which are on an east to west alignment and consist of bowl and disc barrows. These barrows range in size between 11 and 34 metres in diameter. Some of them have a central hollow, which were probably excavated at one time. The others are intact. There are three cross dykes, which are at right angles to the barrow cemetery.

Hill Barn, Folkington: Tumuli
OS Grid Ref: TQ 554 029
There is a linear group of four tumuli at Hill Barn. Three of them are some 140 metres north-east of the ruins of Hill Barn and the other is to the south-west. Two of these are bowl and saucer barrows. They are situated along a ridge in a north-west to

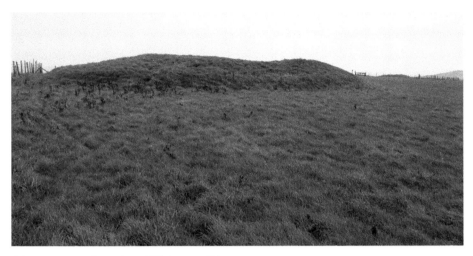

A linear group of tumuli at Hill Barn, Folkington.

south-east alignment. The saucer barrow is a squat, circular mound with a diameter of 8 metres and a height of 0.5 metres. The bowl barrow is about 23 metres in diameter and about 3 metres in height. Both are surrounded by a ditch, which are now infilled.

The bowl barrow, which is the north-western most one has a large central hollow. This was the result of a partial excavation in 1960 and 1973. During these excavations a collared urn was found that dates to the Middle Bronze Age period and contains the cremated remains of human bones. Sherds of Late Bronze Age pottery and some flint tools were also found on the site.

Hove: Round Barrow
OS Grid Ref: TQ 295 046
This barrow, which existed in Hove, was the most impressive of the barrows in Sussex. It was destroyed due to the development of Brighton and Hove in the nineteenth century. The site is on the western side of Palmeria Avenue in Hove, and soil from the barrow was used to build up Palmeria Square. When soil was being removed a coffin with fragments of carious bone were found together with a Celt, whetstone, a bronze dagger and the Hove Amber Cup. The latter is of national and international importance.

The Floral Clock in Church Road was modelled on an old barrow that existed at the northern end of Holland Road. A possible Neolithic long barrow may have existed nearby. There were probably many ancient sites in Brighton and Hove, which are now lost due to development and the sea.

Itford Hill, Itford: Settlement
OS Grid Ref: TQ 447 053
This was a small domestic settlement dating between the tenth and ninth centuries BC. It is situated on the South Downs and overlooks the Ouse Valley. The settlement consists of about seven banked compounds. These are oval and

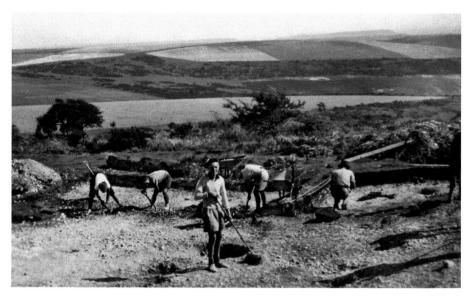

Excavations at the Bronze Age settlement on Itford Hill. (Itford 1949–1953, Burstow XIII 75; courtesy of Sussex Archaeological Society)

rectangular in shape, which measure 10 × 12 metres and 25 × 40 metres. There are a few earthworks on the site today.

During excavations between 1949 and 1952 it was discovered that the compounds contained a number of timber buildings, which represented houses, food and textile preparing huts and stock shelters. Pottery, loom weights, quern fragments and animal bones were also found on the site.

Iping Common: Barrows
OS Grid Ref: SU 855 218
On Iping Common there are a number of barrows dating to the Early Bronze age period. Three of these are quite close together and are on a south-west to

Barrows on Iping Common, Iping.

north-east alignment. The southern barrow is the largest of the three, which has a diameter of 24 metres and 2.2 metres in height. This barrow is surrounded by a ditch, which has since been infilled. The central barrow is the smallest of the three, which has a diameter of 14 metres and a height of 1.3 metres. These barrows are covered in bracken and heather.

Kingston, near Lewes: Barrow Cemeteries
OS Grid Ref: TQ 374 074
A group of four bowl barrows from a barrow cemetery exists on the crest of the hill south of Juggs Road. The largest of them, which includes a mound, has a height of about 1 metre and a diameter of 13 metres. This barrow has a hollow in its centre, which may have been due to a small excavation. The others are only 0.5 metres in height and about 10 metres in diameter. They are all encircled by infilled quarry ditches. The eighteen smaller burial mounds in the vicinity are from an Anglo-Saxon barrow cemetery.

Landport Bottom, Lewes: Barrows
OS Grid Ref: TQ 401 112
The barrows on Landport Bottom date from about 1000 BC. They consist of a row of several mounds running in a south-easterly to north-westerly direction on what was once Lewes Racecourse. One of the barrows is a platform barrow, which has a flat top. It is surrounded by a ditch and external bank. The other barrows are bowl barrows. The tree-lined footpath nearby is on an ancient trackway.

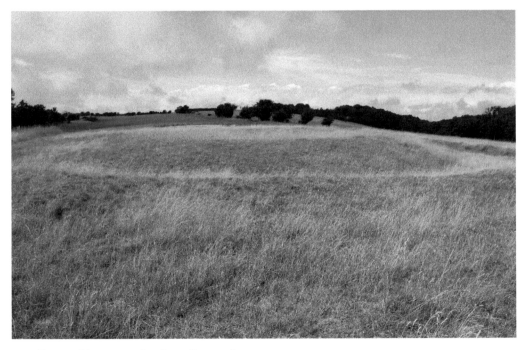

Group of barrows at Landport Bottom, Lewes.

Lord's Piece, Coates: Barrow Cemetery
OS Grid Ref: SU 995 170
Lord's Piece is a heathland south of the River Rother. There are five known barrows on the heath. Three of these make up a linear group and are all about the same size. To the south of them are the other two, which consist of one large and one small barrow and are situated on a small ridge. The larger barrow has a hole to its northern edge, which could be due to an excavation in the past.

Males Burgh: Tumulus
OS Grid Ref: TQ 462 058
This barrow is situated on the top of the South Downs, west of Firle Beacon. It was named after Godfrey le Merle in 1327 as the barrow stood on his land and was originally known as Merle's Bergh. It is situated in a field south of the South Downs Way.

New Barn Down, Patching: Farm Settlement
OS Grid Ref: TQ 084 093
The farm settlement at New Barn Down dates from the Early Bronze Age. The site was discovered by Dr E. Curwen and his son in the early twentieth century. It is situated on the south-eastern spur of Harrow Hill. The site consisted of a few hut sites within an earthwork, visible as shallow depressions in the field, and is rectangular in shape.

The site was excavated by the Worthing Archaeological Society in 1933. Seven of the depressions were excavated, but no artefacts were found in six of them. The other depression turned out to be two pits, which contained artefacts dating to the fourth millennium BC. There are very few signs of the earthworks visible today. A few tumuli exist in the vicinity, but these are quite indiscernible due to much ploughing.

New Hill Barn, Steyning: Cross-spur Dyke
OS Grid Ref: TQ 163 102
This cross-spur dyke crosses two north-to-south spurs that have since been ploughed out. It ran from New Hill Barn to Steyning Round Hill and consisted of a ditch about 5 metres in width and 0.75 metres in depth. The northern end of the cross-spur dyke cuts through the centre of three Bronze Age barrows on Steyning Round Hill. These barrows have been destroyed by ploughing.

Park Brow, Sompting: Settlement
OS Grid Ref: TQ 153 089
Park Brow is a multi-period site dating to the Bronze Age, Iron Age and Romano-British periods. They were discovered in the 1920s in the form of earthworks. Several huts dating to the Late Bronze Age existed here. The walls of these circular huts were built of wattle and daub woven between upright posts. The thatched roofs were conical in shape. One of the huts had a number of pits dug into the floor, which was used for storage.

The multi-period site (Bronze Age, Iron Age and Romano-British) at Park Brow, Sompting, showing slight earthworks.

A bowl barrow exists on the site, which survives in buried form after having been levelled by ploughing. Henry Smail found fragments of a beaker in the 1920s that dates from *c.* 1800 BC. It was found in loose earth, which was thrown up by rabbits. The settlement was abandoned in about 300 BC.

Peacehaven Heights: Bowl Barrow
OS Grid Ref: TQ 431 002
The Brighton and Hove Archaeological Society excavated this bowl barrow, dating to about 1000 BC, in 2008, before it finally succumbs to the sea. The excavations revealed several fragments along with flint tools on the site dating to the Mesolithic period. The barrow would have been a mile or more inland when built, but it is now right on the cliff edge and could be lost to the sea within the next decade or so.

Bowl barrow at the very edge of the chalk cliffs at Peacehaven Heights.

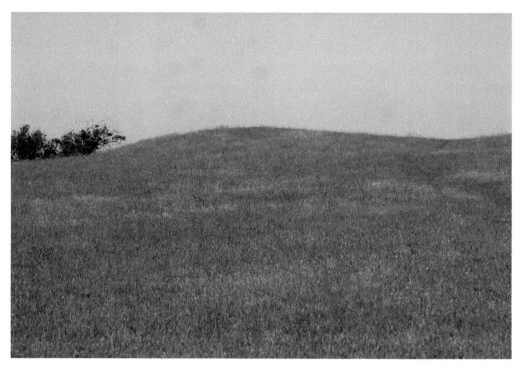

Pedlersburgh bowl barrow on Telscombe Tye.

Pedlersburgh, Telscombe: Bowl Barrow
OS Grid Ref: TQ 396 026
This bowl barrow exists as a roughly circular monument and dates to about 1600 BC. It is in good condition but has had some disturbance by cultivation in the past. A ditch surrounded it, which has since been infilled. The barrow is situated on Telscombe Tye, south of Telscombe village. A large and small urn with overhanging rims was found in this barrow. The former contained burnt bones.

Plumpton Plain, Plumpton: Settlement
OS Grid Ref: TQ 357 122
The enclosed settlement on Plumpton Plain dates from about 1000 BC. It is associated with an unenclosed settlement that dates between 1600 BC and 900 BC. The earthworks represent enclosures, which are donated by banks, lynchets, house platforms and trackways. The banks do not have any ditches. This settlement is in the same style as the one on Itford Hill.

The site was excavated in the 1930s and three roundhouses, Bronze Age pottery (including a storage jar) and cooking holes were discovered. The latter were outside the huts. These excavations also discovered a later settlement that had huts about 400 metres to the south-east, but have since been destroyed by ploughing. A survey by English Heritage was undertaken in 2003 and identified a number of the features that are associated with the settlement.

Earthworks of the Bronze Age settlement at Plumpton Plain.

Pook's Dyke, Itford: Cross-ridge Dyke
OS Grid Ref: TQ 443 051

This cross-ridge dyke is a linear boundary that runs along the slope of the South Downs in a south-west to north-east alignment. It dates from the Late Bronze Age period. The earthworks consist of a bank about 616 metres in length, around 7 metres in width and 1.2 metres in height. There is a ditch on its south-eastern side, which is 5 metres in width and 1 metre in height. The earthwork today is mainly obscured by bushes, but the western end is still visible under turf.

Pudding Bag Wood, Stanmer: Linear Boundary and Barrow Cemetery
OS Grid Ref: TQ 325 095

The linear boundary running north to south dating to the Middle Bronze Age in Pudding Bag Wood has a length of 104 metres. Excavations in 2000 discovered that it has a V-shaped ditch some 4 metres in width and 1.2 metres in depth. Worked flint and sherds of pottery were found during the excavations. The southern end of the earthwork was destroyed by quarrying. Linear boundaries were built to mark important boundaries in the landscape.

Two Bronze Age barrows are situated to the west of the linear boundary. The northern one is a slight mound with a hollow at its centre and is just bare earth

Linear earthwork and barrow in woodland at Pudding Bag Wood, Stanmer.

today. The other is visible as a very slight earthwork. Both are surrounded by ditches, which are now below ground level. As the site is a barrow cemetery, other barrows probably existed here. The whole area today is covered in woodland.

Rackham Banks: Cross Dyke
OS Grid Ref: TQ 051 125
The cross dyke at Rackham, near Amberley, dates from the Late Bronze Age/ Early Iron Age period. It runs in a north-east to south-east alignment for about

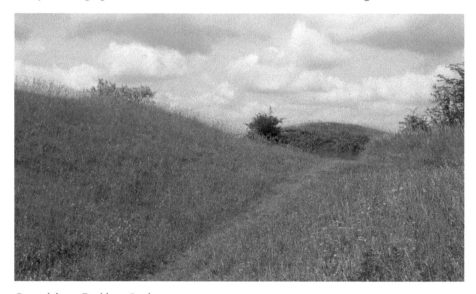

Cross dyke at Rackham Banks.

250 metres and crosses the South Downs Way. It has a large bank that is 3.5 metres high and about 12 metres wide. The monument is flanked by a ditch on its south-eastern side. Some sections have been levelled by long uses of tracks, agricultural activity and ploughing. There was a partial excavation in 1929 where a sherd of pottery was found.

Rookery Hill, Bishopstone: Barrow Cemetery
OS Grid Ref: TQ 467 008
A group of bowl barrows exist on Rookery Hill forming a south-east to north-west alignment, which possibly date to 1600 BC. They are situated on the hill above the village of Bishopstone. The south-easternmost barrow is the largest of them, which is 18 metres in diameter and 1 metre in height. It is surrounded by a ditch. One of the barrows was used in medieval times as a mound for a windmill, which is said to be one of the earliest windmills built in Sussex.

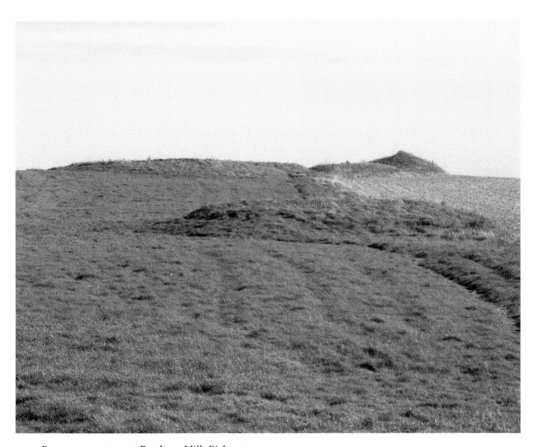

Barrow cemetery at Rookery Hill, Bishopstone.

Round Hill, Steyning: Urn Field
OS Grid Ref: TQ 167 010
One of the best urn field sites existed on Steyning Round Hill. Remains of a broken urn with cremated remains was found in the summer of 1949. The site was excavated by the Steyning Grammar School Archaeological Society in 1949/50. A number of urns with cremated remains were found. The cremations were put onto the ground and an upturned urn placed over them. Some of the cremations were without urns. The majority of the urns dated to the Late Bronze Age period. Fragments of an Early Bronze Age beaker and a Middle Bronze Age collared vessel was also found on the site.

Street Farm, Jevington: Regular Aggregate Field System
OS Grid Ref: TQ 569 017
The regular aggregate field system on the hill east of Jevington dates from the Bronze Age period. The earthworks consist of contour lynchets and cross banks. The contour lynchets are on a north-west to south-east alignment and the cross banks are mainly situated near the foot of the hill. Sherds of Iron Age pottery consisting of coarse, gritty clay with calcined flints were found on the site in 1945.

Earthworks of a Bronze Age field system at Street Farm, Jevington.

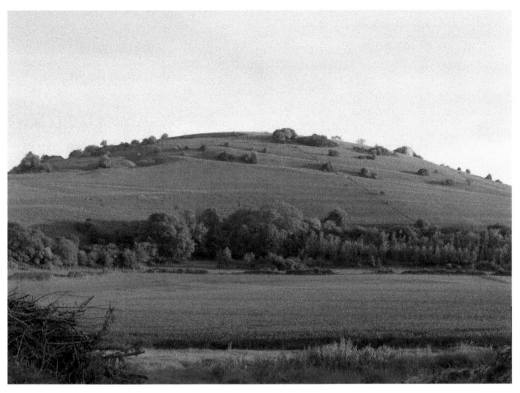

Cross-spur dyke on Sullington Hill.

Sullington Hill: Cross-spur Dyke
OS Grid Ref: TQ 094 123
On the top of Sullington Hill is a cross-spur dyke dating to the Middle Bronze Age. The earthwork was constructed across a chalk spur. It is in a good state of preservation but has had disturbances in the past. It measures 224 metres in length, 8 metres in width and 1 metre in depth. It overlooks Sullington Warren to the north where there is a barrow cemetery. A spur from this cross dyke runs southwards to the sites at Blackpatch, Harrow Hill, Cock Hill and New Barn Down.

Sullington Warren: Barrow Cemetery
OS Grid Ref: TQ 097 144
There are nine barrows on the warren and some are dome shaped. They are situated north of the South Downs on a sand hill in the Weald. Some were opened in 1809 and cremation urns and burnt bones were found in one of them. One of the urns was an over-hanging rim type, which had herringbone patterns on it. The central and largest barrow has a memorial seat at its centre. This commemorates Enid Clarke-Williams, who was secretary to the National Trust in the 1930s.

Round barrow on
Sullington Warren,
Sullington.

Tegdown Hill, Patcham: Disc Barrow
OS Grid Ref: TQ 313 102
There are four barrows on Tegdown Hill and the westernmost one is a disc
barrow. It is circular in shape and has the remains of a central mound. There is an
outer bank around the ditch. An excavation in 1936 revealed a buried pit, which
contained charcoal and worked flints in the centre of the mound. A cup dating to
the Late Bronze Age was found in the ditch, which is thought to have been a burial
deposit.

Bronze Age disc barrow on Tegdown, Patcham.

The Mill Ball, Houghton Bronze Age bowl barrow, which was later used as a windmill base.

The Mill Ball, Houghton: Bowl Barrow
OS Grid Ref: TQ 001 114

This bowl barrow, which dates from the Early to Middle Bronze Age period is situated on downland to the south of Bury Hill and west of the A29 main road. It is 24 metres in diameter and 0.8 metres in height. The surrounding ditch, which no longer exists due to infilling, was about 3 metres in width. Bronze Age, Roman and medieval pottery have been found on the site. In medieval times, the bowl barrow was reused as the base of a windmill. The site is marked on some maps today as 'The Mill Ball'.

West Hill, West Harting: Barrow Cemetery
OS Grid Ref: SU 786 225

An extensive barrow cemetery existed at West Heath that consists of two groups of barrows. These barrows underwent excavations in the 1970s and 1980s and most of them are now obliterated, with just two remaining today. The western group are very close to West Heath Quarry. There are plans to extend the quarry, which could destroy those still in existence. These barrows are not scheduled. Some 400 metres to the north are two bell barrows.

Weston Brow, Westmeston: Barrow Cemetery
OS Grid Ref: TQ 343 129

On Weston Brow is the site of a linear round barrow cemetery. It is on an east to west alignment along a ridge by the South Downs Way. One of the barrows is a bowl barrow, which is 8 metres in diameter and about half a metre in height. It has a ditch surrounding it, which has since become infilled. The hollow at its centre suggests that either an excavation was carried out or that it had been robbed in the past.

IRON AGE

Binsted: Iron Age Ditch
OS Grid Ref: SU 981 061

There is an Iron Age ditch at Binsted which dates from the Middle Iron Age. It comprises of a deep bank, which is double in places and goes from south to north across fields, through woodland, passing under the Black Horse pub and the church to the South Downs where it meets another earthwork known as 'War Dyke'. It used the side of the Binsted Rife as an extra defence. The ditch has been excavated over the years where a lot of Iron Age pottery has been found.

Bullock Down, Eastbourne: Field System
OS Grid Ref: TV 583 963

In the vicinity of Bullock Farm is a field system dating from the Late Iron Age/ Early Roman period. This comprises of an aggregate field system in the form of a settlement and trackway. The site has been partly levelled by ploughing, but some of the earthworks still survive about 640 metres south-west of Bullock Down Farm. The earthworks were probably the remains of settlements or farmsteads.

During the twentieth century a number of Roman silver and bronze coin hoards were found on the site dating from AD 196 to 266. An excavation between 1976 to 1980 by the Sussex Archaeological Field Unit revealed Romano-British settlement remains. Finds included tile, pottery and corn-drying ovens. Artefacts dating from the Mesolithic period were also found in the area. Another find was a flint-working floor, which is possibly Neolithic in date.

Castle Hill, Newhaven: Hillfort
OS Grid Ref: TQ 445 000

The hillfort at Castle Hill, Newhaven, is situated on the cliff edge, but was probably more than a mile inland when it was constructed. It is now totally destroyed due to activities over the years. A vast quantity of pottery of varying ages has been found on the site, which means that occupation has existed here from the Late Bronze Age to the third century AD. Some bronze tools have also been found here.

Castle Hill, Woodingdean: Hillfort
OS Grid Ref: TQ 378 068

The date of the enclosure on Castle Hill, near Woodingdean, is uncertain but it is believed to be Iron Age. The name Castle Hill does suggest a hillfort or camp.

It is rectangular in shape and consists of a bank only a metre or so in height and a ditch. There are a few depressions within the enclosure, which might be the site of huts. Castle Hill is a nature reserve.

Chanctonbury Ring: Hillfort
OS Grid Ref: TQ 139 121

The univallate hillfort at Chanctonbury Ring is thought to date from the Late Bronze Age or Early Iron Age period. Its construction is uncertain, but it could have been used for defence, an enclosure for cattle or for a variety of purposes. It consists of a roughly circular low earthwork with a bank and ditches. There is only one entrance, which is at the south-western end. The southern end of the hillfort is well preserved. Two Roman temples were built with the hillfort, which were in use between the first and fourth centuries AD.

Charles Goring of Wiston Estate planted beech trees on the earthwork in 1760, which were mainly blown down in the hurricane of 1987. Excavations were carried out on the site in 1869, 1909, 1977 and 1988–91. The latter was prior to replanting trees. Neolithic and Early Bronze Age activity was found, but no sign of any settlement or occupation. There are some Bronze Age barrows east and west of the hillfort.

The Late Bronze Age/Early Iron Age hillfort at Chanctonbury. A Bronze Age barrow is in the foreground.

Chelwood Gate, Ashdown Forest: Enclosure
OS Grid Ref: TQ 413 309
The enclosure and associated earthworks at Chelwood Gate dates from the Late Iron Age and its purpose was probably a farmstead. It is a five-sided, oval-shaped enclosure containing a bank and ditch. It is 87 × 67 metres in diameter and about 0.6 metres in height. There are six entrances to the enclosure, but some of these may have been added at a later date. It is known as 'the Danes Churchyard'. An excavation in 1860 revealed no finds. The site today is very overgrown.

Chichester: Entrenchments
OS Grid Ref: SU 850 067
The Chichester entrenchments are linear earthworks, which are either Late Iron Age or Early Roman in date (between 100 BC and AD 43). They consist of banks and ditches. They were built as defences to the territory from attacks by rival tribes. Excavations in some of the banks revealed no dating evidence. Some of the old entrenchments may have been reused in medieval times. Most of the earthworks are now covered in woodland.

The linear earthworks of the Chichester Entrenchments in Brandy Hole Lane, Chichester.

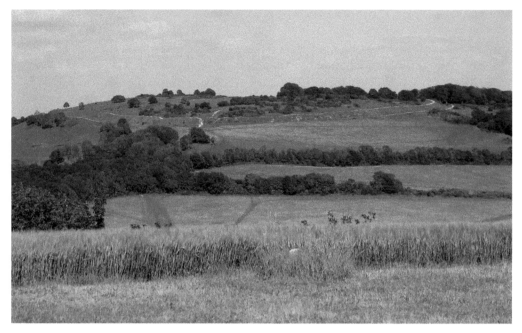

Ramparts of the Iron Age hillfort at Cissbury.

Cissbury: Hillfort
OS Grid Ref: TQ 139 080
The hillfort at Cissbury is the second largest in the country – Maiden Castle in Dorset being the largest. It was built around 300 BC when most of the smaller ones came out of action. Some 60,000 tons of chalk, flint and soil were used in order to build up the ramparts and ditch. The site encloses 65 acres and it has a south and east entrance. When built, it was white with chalk and showed up as a monument for miles around.

It consists of an outer and inner rampart with a ditch between them. The inner ditch was once surrounded by a wooden revetment, which consisted of between 8,000 and 12,000 timbers. It is not certain if the hillfort was built as a defence against tribes or as a meeting place. As a defence, it would have taken thousands of people to defend it, although only the entrances would have been guarded. The ditch may have had brambles growing around it as a deterrent. The hillfort was re-fortified in the Roman period.

Copse Farm, Oving: Late Iron Age Farm
OS Grid Ref: SU 897 057
A Late Iron Age settlement existed in the area of Copse Farm, north of Oving. The site was excavated between 1980 and 1983 and comprised of a rectangular enclosure with a timber roundhouse at the east end. This settlement was an Iron Age farm where remains of horses, sheep, pig, cattle and barley were found. The finding of amphorae on the site suggests that the farm also traded in wine.

Cowbottom Hovel, Applesham: Field Systems
OS Grid Ref: TQ 188 071
A few earthworks have been recorded at Cowbottom Hovel and Barn, which probably date from the Late Iron Age and early Roman periods. These earthworks are mainly visible from aerial photographs, but there are some that can be seen from the ground. In the case of Cowbottom Barn, fragments of Iron Age pottery were found. At Applesham Farm, to the east, a bronze object was found in 1940, which could have been a lynch pin from an Iron Age chariot.

Devil's Dyke, Poynings: Hillfort
OS Grid Ref: TQ 260 111
The large univallate hillfort at Devil's Dyke possibly dates from the Early Iron Age period. It has ramparts and a ditch. It is not known if it was used for defence, just to keep animals out or as a refuge for local folk during raids. The ramparts are very small in places, but the western ramparts are the highest of them. The site of huts exists within the hillfort. During excavations in 1935 the remains of a roundhouse, refuse pits and sherds of pottery dating between 50 BC and AD 50 were found.

The legend of Devil's Dyke is that the Devil wanted to drown the villages who turned to Christianity in the seventh century AD by digging a channel to let the sea in. God said to him, 'Go ahead, but when the sun comes up, you must abandon it.' While he was digging away, an old lady came out to see what the noise was about and she had a light. The Devil saw this and thought it was the sun so he abandoned the work, which was left unfinished.

The hillfort earthworks at Devil's Dyke.

The scanty remains of the hillfort on Ditchling Beacon.

Ditchling Beacon: Hillfort
OS Grid Ref: TQ 332 131
This hillfort dates from the Early Iron Age, and the steep northern slope was used as a natural defence. The ramparts were still visible until the 1940s when ploughing destroyed most of them. Only the northern section of the ramparts can still be seen today. The earthworks were of an irregular quadrilateral form. Excavations were carried out at the hillfort in 1929 where several sherds of Roman pottery were found. A trial excavation took place here in 1983. A total of five trenches were dug where traces of the bank and ditch plus Iron Age pottery were found.

East Hill and West Hills, Hastings: Promontory Hillforts
OS Grid Ref: TQ 833 097 and TQ 825 094
This hillfort on East Hill dates from the Middle Iron Age and was probably a promontory fort. It has earthworks and an internal area that is defended by the steep cliffs on three sides. The main structure is on the north-eastern side of the hill and consists of a bank and ditch. This is 30 metres in width and only 4 metres in height. No settlement was found within the fort. Many pottery sherds were found in the area dating between 200 BC and AD 50.

The promontory hillfort on West Hill known as 'Ladies' Parlour' dates from the Middle Iron Age. It was a defensive enclosure and occupied the whole promontory. Hastings Castle, built in 1066, occupies half of its site at its western end. A ditch of the earthwork runs north-west to south-east between Castle Hill Road and the edge of the cliff. An excavation in 1968 found two ditches, part of a rampart and pottery dating between 300 and 100 BC. The southern end of the fort has probably been lost due to cliff erosion.

Remains of promontory forts at Hastings. West Hill is in the foreground and East Hill is in the distance.

Findon Park, Findon: Farm Settlement
OS Grid Ref: TQ 141 094

This was a small settlement, and eleven store pits were excavated by Sir Cyril Fox and Garnet Wolseley between 1925 and 1927. A vast amount of pottery and a brooch were discovered here. In one of the pits the skull of an ox was found surrounded by a ring of flints. This suggests some kind of ritual practice had taken place here. The site lies in a field east of the footpath from Cissbury to Chanctonbury and is in a small, wooded area to preserve it. A few ancient trackways lead to the settlement, which can be seen from the top of Cissbury.

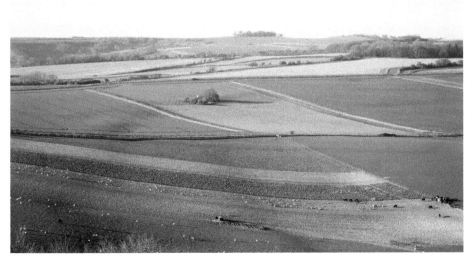

Site of the Iron Age farm settlement at Findon Park, Findon. The view is from Cissbury, showing trackways leading to it.

Garden Hill, Hartfield: Hillfort
OS Grid Ref: TQ 474 313

This small Iron Age hillfort was first identified in 1968 by C. F. Tebbutt. Its defences enclose a rectangular area, which are formed by a slight bank. It is situated in the Ashdown Forest, west of the long-distance footpath 'Wealdway'. Excavations between 1969 and 1982 show that the inner side of the bank was revetted by a drystone wall and had vertical timbers. Although the walls have become ruinated, some stonework can still be seen in the ramparts.

Iron Age occupation was discovered on the site, including roundhouses. Roman occupation has also been found, which includes a small stone-built bathhouse dating to the second century AD. Iron making (ore roasting and smelting) and iron working (forging) were carried out on the site. The south-eastern side of the fort is best preserved. The site can get very overgrown.

Goosehill: Multiple-enclosure Fort
OS Grid Ref: SU 830 127

This multiple-enclosure fort consists of a double circuit of ramparts, ditches, banks and entrances. It dates from the Late Iron Age between 350 BC and about AD 50. The site is now mainly covered with trees. It is situated on sloping ground on Bow Hill. There is one entrance at the inner closure and two hut sites.

An excavation between 1953 and 1955 revealed that the ramparts were V shaped and artefacts such as Iron Age and Roman pottery were found. Circular depressions within the enclosure proved to be small Iron Age buildings. Postholes, daub fragments and charcoal were also found on the site. Some excavations took place at Goosehill in 2008/09 and it was also included in a field survey of the area between 2014 and 2016.

Hammer Wood, Iping: Hillfort
OS Grid Ref: SU 846 240

This is a small multivallate hillfort that overlooks the River Rother. The north-eastern side of the hillfort survive as two parallel banks, which are flanked by outer ditches. An excavation in 1957 showed that the earthen and rubble banks are revetted with ironstone slabs, which were extracted from the locality. Within the hillfort are roundhouses, outbuildings, granaries, iron-smelting hearths and pits. The site is covered in woodland.

Harting Beacon: Hillfort
OS Grid Ref: SU 808 184

The hillfort on Harting Beacon dates from the Late Bronze Age/Early Iron Age period, but its defences were rebuilt sometime in the Late Iron Age. It is the largest of the early hillforts. It has a single ditch and bank and has only one entrance on its west side. A timber gate was built within the entrance. The fort is about 500 metres north to south and around 400 metres east to west.

An Iron Age hillfort at Harting Beacon.

Excavations of the hillfort took place between 1948 and 1952 and in 1976/77. Pottery, animal bones, fragments of querns, a loom weight, penannular rings and spindle whorls were discovered. The finding of mollusc remains show that the area was overgrown grassland during the Iron Age period.

Highdown: Hillfort
OS Grid Ref: TQ 093 044
The earliest known settlement on Highdown was an enclosure, which was probably a meeting place dating to the Late Bronze Age period. The Iron Age hillfort that replaced it dates from about 600 BC and consists of a single rampart and ditch. The southern and eastern defences had a second rampart and ditch added at a later date. There are entrances to the fort at the eastern and south-western ends. Sherds of Iron Age pottery were found below the ramparts.

The hillfort was re-fortified in the Roman period. An Anglo-Saxon cemetery was erected within the fort in the fifth century AD. Highdown has been excavated on several occasions; the last time was a rescue dig in 1988 after the 1987 hurricane. Many artefacts were found at Highdown during these excavations and are on display in Worthing Museum, the best find being the Anglo-Saxon Highdown Goblet.

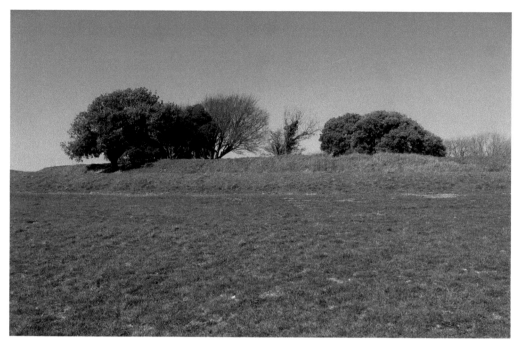

The hillfort earthworks at Highdown.

High Rocks, Tunbridge Wells: Hillfort
OS Grid Ref: TQ 561 382
The multivallate hillfort at High Rocks was originally a univallate hillfort thought to have comprised of a single bank and ditch. There was evidence of an entrance with a gate and a palisade. The hillfort had other banks and ditches added to it at a later date. The finding of pottery on the site indicated that the fort was in occupation between 150 BC and 100 BC. Romano-British occupation was also found on the site.

Hollingbury, Brighton: Hillfort
OS Grid Ref: TQ 322 079
The hillfort at Hollingbury dates to the Early Iron Age period. It consists of a single bank and ditch. The hillfort has east and west entrances. E. Curwen excavated the site in 1931, which revealed postholes by the east entrance and at the north-eastern side. This showed that the rampart of the hillfort was once a box rampart that had timbers for reinforcement and was filled with rubble.

An excavation in 1967–69 found the site of five roundhouses that date to the sixth century BC. They vary in size between 4.25 and 12.25 metres. This represents either a small village or farmstead. The discovery of a loom weight fragment and piece of quern stone meant that weaving and corn production took place here. The excavations also discovered that the hillfort was reused in the Roman period. Within the hillfort are three Bronze Age bowl barrows.

Ramparts of the hillfort at Hollingbury, Brighton.

Lancing Down: Iron Age Shrine and Roman Temple
OS Grid Ref: TQ 177 068
A small Roman temple existed on Lancing Down together with an Iron Age shrine. The temple was discovered in 1828 by the landowner, who charged people to come and look at it. When people started going to the newly discovered Bignor Roman villa instead, so the landowner covered over the site. The temple was

Site of the Iron Age shrine and Roman temple on Lancing Down. Steep Down is in the distance and the site of Iron Age burials is in the foreground.

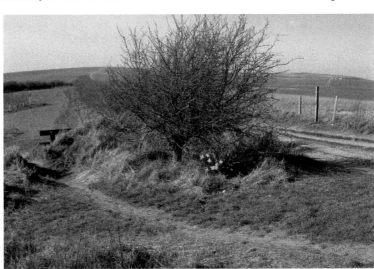

40 square feet with a central shrine, which had a mosaic floor. The Roman temple is aligned with Bronze Age barrows on Steep Down further to the north.

During excavations in 1980 a Late Iron Age shrine was discovered. This was a small timber-framed building that comprised of a square within a square. The temple and shrine are situated at the south-eastern corner of a temonos, which is an oval-shaped enclosure measuring 40 × 30 metres. The ring is only about 65 cm thick. There are a few Iron Age burials south of the Roman temple site.

Lancing Hill: Terraceway
OS Grid Ref: TQ 186 067
A wandering earthwork dating to the Iron Age runs along the Downs from Lychpole Bottom to Lancing Hill via Steep Down. It traverses the southern end of the latter. This earthwork was marked as 'Roman Ditch' on earlier OS maps, but Hadrian Allcroft pointed out that it is neither a ditch nor Roman in date. It is a terraceway, which is either a covered way or sunken cattle track. The terraceway is still visible along the top of the hill with trees along its course, but its site is lost east of Lancing Hill.

Long Furlong, Clapham: Celtic Field System
OS Grid Ref: TQ 094 075
A Celitc field system existed on the hill north of Clapham and just south of the Long Furlong Road (A280). This was in use between 500 BC until about the end of the Roman period and/or early Saxon period. There are earthworks on the site, which consist of hollow ways, lynchets and other humps and bumps on the slope of the hill. A sunken trackway runs from the field system towards the south-east.

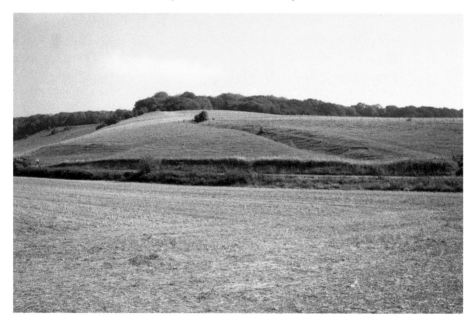

Earthworks of the Iron Age/Roman Celtic field system at Long Furlong, Clapham.

Hillfort at Mount Caburn, Glynde.

Mount Caburn, Glynde: Hillfort
OS Grid Ref: TQ 444 089
This hillfort, which dates to about 400 BC has a V-shaped ditch with a bank. It is situated on the summit of the hill overlooking the River Ouse. There have been a number of excavations here over the past 140 years: by Pitt Rivers in 1877/78, E. Curwen and his son in 1925/26 and 1937/38, and the Sussex Archaeological Society from 1996 to 1998. These excavations total 170 trenches. Burial pits were found here where human remains, weapons, tools, coins, querns and pottery were found.

It was thought that the hillfort was used as a defence due to its location, which overlooks the Ouse Valley and the South Downs. As the rampart is not very substantial, it may have been used as a refuge point instead. The most recent excavations showed that the hillfort was a religious site rather than a defensive fort or farmstead.

Muntham Court, Findon: Multi-period Site
OS Grid Ref: TQ 111 093
The multi-period site at Muntham Court is situated in a field at the top of a hill to the north-west of Findon. The first period is a Late Iron Age settlement, which was partly enclosed by a palisade with a shallow ditch. The settlement consisted of numerous postholes, which mark the sites of huts and corn-drying racks.

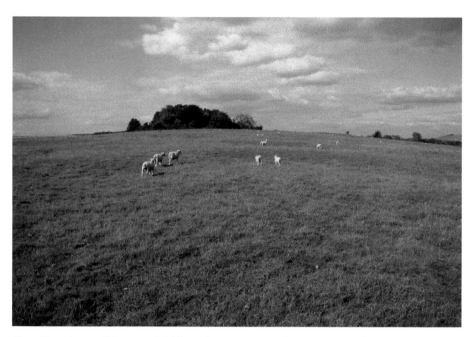

Site of Iron Age and Romano-British settlements at Muntham Court, Findon.

A Romano-British temple and shrine was built on the summit of the hill. The temple is a circular building 11 metres in diameter and the shrine consisted of two wooden structures.

The site was excavated by G. P. Burstow and G. A. Holleyman in the 1950s. An extensive settlement of house structures, trackways, field boundaries, a temple and shrine were revealed. Artefacts on the site include Iron Age and Roman pottery, spindle whorls and loom weights. The best find is that of a bronze boar, which is now on display in Worthing Museum and Art Gallery.

Park Brow, Sompting: Settlement
OS Grid Ref: TQ 154 091
The Iron Age settlement at Park Brow was situated north-east of the Bronze Age site and dates from about the third century BC. Their huts were large and rectangular. Deep pits were dug into the chalk Below their floors as well as in the vicinity. These were used to store corn and food. When the pits were put out of use, rubbish was put into them. These were fragments of pottery, saddle querns, loom weights, spindle whorls and weaving combs. An earthwork was constructed around the settlement.

During excavations on the sites, animal bones, pottery, loom weights, fragments of querns and a small urn containing a cremation burial were found. The most important discovery was a silver finger ring dating between 325 and 250 BC. The Romano-British settlement was built south of the Bronze Age site. There were extensive earthworks on the sites at one time, but due to much ploughing these are now very slight.

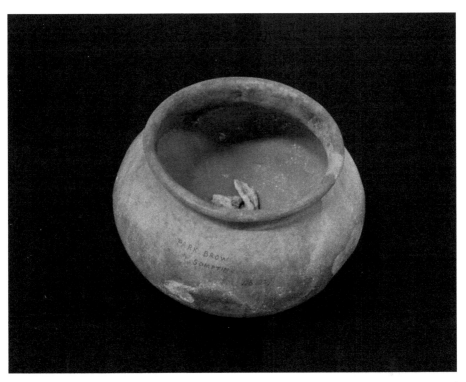

Pot with cremated remains from the Iron Age settlement at Park Brow, Sompting. (Courtesy of Worthing Museum and Art Gallery)

Philpots, West Hoathly: Promontory Fort
OS Grid Ref: TQ 349 322

This promontory fort is situated on the hill above the Big Upon Little rock shelter. It utilised the natural defences at its south-west and south-east ends. There was a partial excavation of the site in 1931 where it was found that the fort was constructed of dumped soil (the ditch once being flat bottomed) and fragments of charcoal were discovered. The latter seems to indicate that the banks would have been topped with a timber palisade. The ramparts are denuded today and are on private grounds.

Piper's Copse, Northchapel: Enclosure
OS Grid Ref: SU 978 296

This small enclosure seems to have been a fortified mining camp, as were others in the Weald. It has strong ramparts consisting of a bank and ditch. It is the only fort on low ground in Sussex and is about 40 metres above sea level and near to a stream. A small iron-smelting hearth was unearthed by a fox in the twentieth century. This contained iron slag, charcoal and sherds of Late Iron Age pottery. The fort is covered in dense woodland and is on private property, but the earthworks can be glimpsed from Pipers Lane.

Rackham: Unenclosed Urn Field and Enclosure
OS Grid Ref: TQ 052 125
The unenclosed urn field about 900 metres south of Rackham Farm is represented by two grave mounds, which are on a north-east to south-west alignment. One of the mounds is uneven and is 12 metres in diameter and 0.75 metres in height. The grave mound was investigated in 1929 and a cremation burial and fragments of an Iron Age cinerary urn were found. The other mound has a diameter of about 9 metres and about 0.3 metres in height. It is unlikely any unmarked burials around the area of the mounds have survived.

An enclosure is associated with the urn field. This is a contemporary ritual monument and lies between the grave mounds. It consists of a sub-rectangular platform 12 metres by 10 metres and is on an east to west alignment. The monument has a low bank 0.5 metres in height and 6 metres in width. During a partial excavation in 1929, it was discovered that the central area was paved with flint nodules.

Ranscombe Hill, Glynde: Camp
OS Grid Ref: TQ 438 091
The camp on Ranscombe Hill dates from the sixth century BC. It is a large, unfinished univallate hillfort, which was probably never occupied. The existing earthworks consist of a bank and ditch on the eastern side, which is about 400 metres in length and about 2 metres in height. The hill west of the hillfort has cultivation scarps across it. A partial excavation in 1959/60 revealed second-century pottery, which suggests that the hillfort was also occupied during the Roman period.

Rookery Hill, Bishopstone: Settlement
OS Grid Ref: TQ 467 007
The Iron Age settlement on Rookery Hill probably dates to *c.* 500 BC. It is within an enclosure that is outlined by a ditch. Pottery, weaving work and also salt boiling are evident in the settlement. The settlement was probably a small farm, which utilised the fields on the downland and the Ouse estuary below. It is possible that part of the site served as a cattle corral.

Saxonbury Hill, Rotherfield: Hillfort
OS Grid Ref: TQ 577 329
The hillfort on Saxonbury Hill dates to the Early Iron Age period and is situated in the Weald on a sandstone hill. It appears today as a slight earthwork with a bank and ditch with a height of 1.5 metres. An excavation in 1929/30 revealed that it was constructed of earth and stones. The foundations of an earlier enclosure, pottery and Iron Age slag were also found. Within the hillfort are the buried remains of houses, granaries and storage pits. A folly known as Saxonbury Tower was built within it in the nineteenth century.

Hillfort site with a nineteenth-century folly within it at Saxonbury, Rotherfield.

Seaford Head: Hillfort
OS Grid Ref: TV 494 978

The large univallate hillfort on Seaford Head dates from about 600 to 400 BC and is situated on top of the cliffs. This fort was considered to have been a promontory fort by General Pitt Rivers. Half of the hillfort has been lost to the sea by cliff falls over the centuries. It was complete in 1587 when two beacons were erected on the hill for the Spanish Armada threat of 1588.

The hillfort was excavated in 1876 by Pitt Rivers and James Park-Harrison. Romano-British pottery was found together with other Romano-British occupation. It was further excavated in 1983. The surviving earthworks consists of a large bank and outer ditch. There are two entrances to the fort on the east and north-west sides. The north-western end of the ditch is well preserved. Within the western side of the hillfort is an Early Bronze Age bowl barrow.

The Iron Age hillfort at Seaford Head is very close to the cliff.

Selsey: Possible Site of Oppida
OS Grid Ref: SZ 856 920

An oppida may have existed at Selsey, which was possessed by the Atrebates tribe in the first century BC. An oppida served as the site of a tribal mint and probably the king's court. The site of the Selsey oppida is uncertain and is believed to have been south of Selsey Bill, now lost to the sea by coastal erosion. A number of gold coins were found on the beach there. It is also possible that the oppida may have been at Chichester instead or moved there from Selsey.

Site of the Iron Age oppida now in the sea at Selsey.

Slonk Hill, Shoreham: Small, Enclosed Settlement
OS Grid Ref: TQ 230 070
Ancient sites on Slonk Hill were first indicated in 1914 when an army division had been encamped on the South Downs, north of Shoreham. Excavations revealed a small, enclosed Iron Age settlement dating from the sixth to first century BC. There is evidence of agriculture, metalworking and domestic occupation on the site. Timber structures and two inhumations were discovered. Sherds of Iron Age pottery were found in ditches, gullies and postholes.

Tenants Hill, Cissbury: Ancient Trackway
OS Grid Ref: TQ 149 070
An ancient trackway goes along the ridge of Tenants Hill, which was used from the Iron Age to the Roman period. The trackway exists on the hill as a slight agger just west of the footpath from Charmandean, Broadwater. It was probably used by folk travelling to and from the hillfort at Cissbury. Tenants Hill is named from tenant farmers who worked the land here.

 South of this, the route exists as a footpath and twitten known as 'The Quashetts' and then along Worthing High Street to the sea. Worthing's Roman grid system of centuriation may have been based on this trackway. The trackway probably went northwards to Chanctonbury and then to the Weald. It was probably used as a drove road in medieval times to take cattle and other livestock to market.

The Trundle, Singleton: Hillfort
OS Grid Ref: SU 877 111
This hillfort was occupied between the fifth and first centuries BC. It was built of a high circular earthwork consisting of a bank, ditch and ramparts. There were two gates at the east and west ends of the hillfort. There would have been a wooden

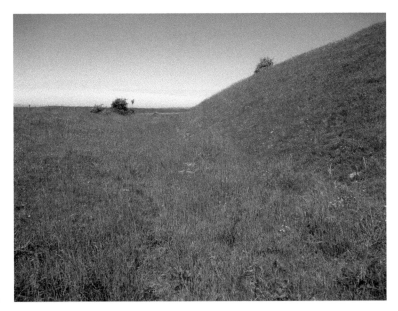

Hillfort at The Trundle, Singleton.

palisade on the top and it had two gated entrances. All that remains of it today is its outer bank. Its strategic position on the South Downs, with the sea to the south and Weald to the north, gave protection and a good focal point for trade.

A number of large internal pits exist within the hillfort that were probably used for storage – possibly wheat. E. C. Curwen underwent digs at The Trundle in 1928 and 1930, where he excavated ditch segments and pits. Within the hillfort is the site of a medieval chapel and post-medieval windmill. These are represented by mounds.

Thundersbarrow Hill: Hillfort
OS Grid Ref TQ: 229 083

This hillfort consisted of a four-sided enclosure some 250 feet in diameter and it is surrounded by a slight bank and ditch. This was later enlarged with a nearly circular earthwork about 470 feet in diameter, which also has a bank and ditch. There are two entrances. The fort does not seem to have been strengthened by a palisade. The site has been largely levelled by ploughing, but the earthworks still survive as a raised bank.

The purpose of this fort may have been used as a refuge for the people of nearby farms during raids rather than a military fort. A partial excavation of the site in 1985 revealed worked flints, fragments of bone and sherds of pottery. Just to the south is a Bronze Age bowl barrow, which gives the hill its name. East of the hillfort is a Romano-British village and a field system to the south-west.

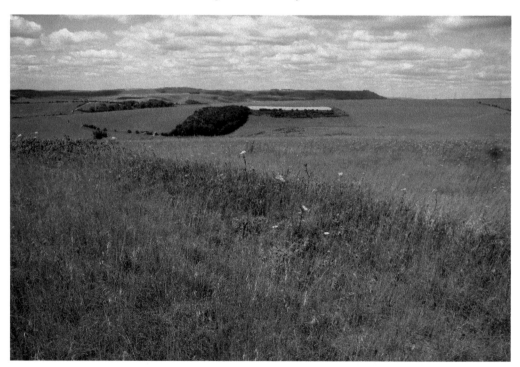

The small hillfort at Thundersbarrow Hill.

Remains of the hillfort at Torberry Hill, South Harting.

Torberry Hill, South Harting: Hillfort
OS Grid Ref: SU 780 203

This is a contour hillfort that was discovered in 1948. It consists of a rampart and ditch, which followed the contour of the hill. Because of much ploughing of the site, excavations were difficult, but they proved that the hillfort was an important place during the Iron Age. It is thought that the hillfort was in use between the fifth to first centuries BC. Legend has it that the hillfort was formed by the Devil's spoon as he flung away his punch while supping from the 'Devil's Punchbowl' in Surrey.

War Dyke, Arundel: Iron Age Ditch
OS Grid Ref: TQ 008 107

This monument is a linear boundary with linear earthworks that are situated on the slopes of a hill north of Arundel. It goes from Rewell Hill Wood and descends eastwards to the River Arun, near North Stoke, via Whiteways Lodge. At the river's end the dyke has been lost due to a quarry. It is not certain what the purpose of the earthwork was, but it has similarities to the Chichester entrenchments. It was probably used for defensive reasons.

Wolstonbury Hill: Hillfort
OS Grid Ref: TQ 284 138

This hillfort dates from the Late Bronze Age/Early Iron Age period. It is aligned north to south and roughly oval in shape. The hillfort consists of a bank and ditch,

but the ditch is on the inner side of its bank. The ramparts are small. There are two entrances to the fort at the northern and south-eastern ends.

Excavations by E. Curwen and Madame de Marees Van Swinderen in 1929 revealed that this fort was mainly built as a temporary refuge. It was once thought that it could have been a Neolithic enclosure, but this has since been disproved. There are burials with grave goods within the fort that are possibly Anglo-Saxon in date, which were disturbed by later flint digging.

The hillfort at Wolstonbury.

7

OTHER SITES AND FINDS

As well as the well-known archaeological sites in Sussex, many others have been discovered over the years by the finding of artefacts, such as pottery in fields, downland and the coast. Earthworks of unknown and known sites can sometimes show up in crop marks in fields, indicating where they once existed. Some isolated finds such as flint implements, pottery, brick and tile may suggest a potential site and some of these still need to be confirmed by archaeologists. Hoards such as coins and axes may suggest a site or they could have just been buried to hide from enemies or as an offering.

A number of sites have been discovered during development of the area such as housing estates and bypasses. Excavations on these sites were carried out prior to any development, rescuing what archaeology existed there. Known archaeological sites that may be threatened by development are also excavated beforehand. Examples of some of these sites are mentioned below.

One case was the Hill Barn housing estate at Sompting, near Worthing. A Late Bronze Age hoard was discovered in 1946 and excavations revealed a cauldron dating to 800 BC, a boss (possibly part of a shield) and socketed axes. This hoard may have been buried here as an offering. These are on display in Worthing Museum.

During the proposed development on land at the back of a few houses in Upper Bognor Road, Bognor, an excavation of a Mesolithic occupation site was carried out. The excavation revealed features and produced Mesolithic flintwork. Some of these flints were cores, flakes and waste flakes. Worked flint from the Neolithic and Bronze Age periods were also found on the site.

An Iron Age warrior's grave was discovered during development at North Bersted, near Bognor, dating to 50 BC. He is known as 'The Mystery Warrior: The North Bersted Man'. The grave was discovered by Thames Valley Archaeological Services in 2009 prior to the constructions of houses. The warrior's grave was elaborately equipped.

In Walberton, near Barnham, a rare Iron Age grave of a warrior was discovered in 2020 during the construction of a housing estate. Archaeology South-East (ASE) excavated this and they unearthed the grave, which dates from either the Late Iron Age or Early Roman period. The grave was furnished with weapons and some pottery vessels. No human remains were found – they were probably disintegrated due to the soil in this area.

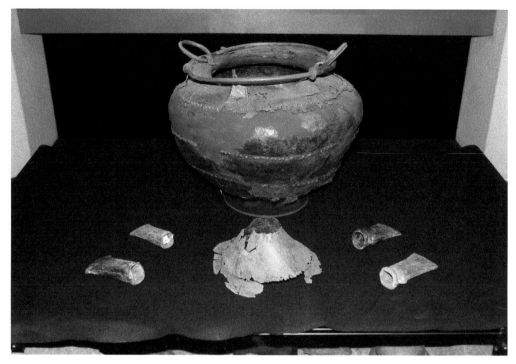

Bronze Age cauldron, boss and axe hoard found at Hill Barn, Sompting. (Courtesy of Worthing Museum and Art Gallery)

During the housing development at Chamandean in Broadwater in the 1960s, a cremation urn was discovered on the Hill Barn Golf Course to the north. The urn dates from the Late Bronze Age period and has lugs on it. The urn contains the cremated remains of a woman. This is on display in Worthing Museum.

Prior to the A27 Brighton bypass a number of excavations were carried out on the route beforehand. Sites excavated were at Mile Oak in Portslade, Hangleton, Red Hill and Coldean among others. This was during the late 1980s and early 1990s. That at Red Hill was a Mesolithic site where a vast amount of flint implements were found, and at Coldean was the site of a Bronze Age settlement. At Mile Oak a Neolithic henge and crouched burial was found. The henge was completely destroyed by the bypass and it was similar to the one at Cock Hill, Patching.

Prior to the Angmering bypass (A280) excavations in 2001 revealed Bronze Age, Iron Age and Saxon inhabitations. Pottery sherds, postholes, burnt flints and an indication of a cremation were found. Flint tools and flint chippings also came to light, meaning that Mesolithic and Neolithic activity also occurred in the area.

During the construction of the Rampion Wind Farm, excavations were carried out in the Weald, on the South Downs and coastal plain when a pipe was being laid through. One of these was the excavation of a Bronze Age cross dyke at Tottington Mount, near Edburton, where pottery was found. Nearby the site of a warrior on Beeding Hill was excavated, which dates to the eleventh century.

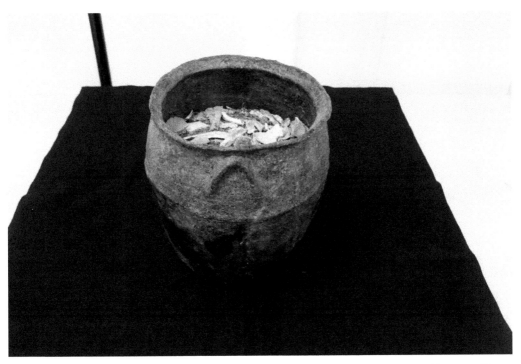

Late Bronze Age cremation urn with the cremated remains of a woman found at Hill Barn Golf Course, near Charmandean, Broadwater. (Courtesy of Worthing Museum and Art Gallery)

Site of the Neolithic henge monument now under the A27 bypass at Mile Oak, Portslade.

During works (such as dredging) along rivers, streams, lakes and ponds, sites and/or artefacts have been found. One example of this was in 1983 when the Ferring Rife in Ferring was being widened. A hoard of ten socketed axe heads dating to the Late Bronze Age (800 BC) were discovered together with two fragments of a rare bronze sword, woodworking tool and a belt buckle. This hoard was found on the border between dry and waterlogged land and suggests that it was probably placed here for religious purposes. These are on display in Worthing Museum.

There will be more developments in the future and archaeologists will excavate any ancient and possible sites before they are lost under houses and roads forever. Hopefully some sites of archaeological importance will be spared and kept for future generations to enjoy. This has happened in many places with a plaque giving details of their history.

A great number of ancient sites have been lost to the sea by coastal erosion over the centuries. The coast was much further out at one time, and before the last Ice Age Britain was connected to the rest of Europe. Recently, some Ice Age deposits were revealed at Climping Beach during the repairing of sea defences. Where there are sea cliffs many long barrows, tumuli, hillforts and settlements could be lost due to coastal erosion. After storms it is possible that artefacts of varying ages could be revealed and washed ashore.

At Heene, west of Worthing, a dug-out boat was found lying in mud about 185 metres from the beach opposite Heene Road after a severe storm in 1842. It was made from a hollowed-out trunk of an oak tree and had a square-cut bow and stern. It measured 4 metres in length and 1 metre in width. This boat

A contemporary illustration of the prehistoric dug-out boat found on the beach opposite Heene Road, Heene. (Courtesy of Worthing Museum and Art Gallery)

was probably pre-Roman in date (possibly Iron Age). Unfortunately it has not survived, but there is a contemporary illustration of it.

The coast of Sussex was some 8 km further out in Mesolithic times and the coastline, in the case of Worthing, would have been where the wind turbines are now. The coastal plain is a very good area for Mesolithic sites. The author has found some Neolithic flint implements and Roman brick and pottery on Worthing Beach. There is probably a lot of archaeology waiting to be discovered out at sea.

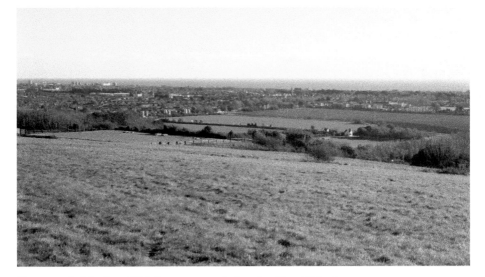

The coastal plain from Highdown – a good place for Mesolithic sites.

The present coastline in Worthing. The coastline in Mesolithic times was where the wind turbines are now.

Stone Age artefacts found by the author on Worthing Beach. These would have been washed ashore in recent times.

BIBLIOGRAPHY

Allcroft, A. H., *Earthwork of England* (Macmillan and Co. Ltd, 1908)

Armstrong, J. R., *A History of Sussex* (Phillimore, 1995)

Brandon, P., *The Sussex Landscape* (Hodder and Stoughton, 1977)

Burstow, G. P., 'The Stone Age Camp at Whitehawk' in *Sussex County Magazine*, Vol. XVI, No. 4 (November 1942), pp. 314–19)

Butler, C., *Prehistoric Flintwork* (The History Press, 2012)

Curwen, E. C., *The Archaeology of Sussex* (Metheun and Co. Ltd, 1954)

Dinnis, R. and C. Stringer, *Britain: One Million Years of Human History* (National History Museum, London, 2017)

Drewett, P., D. Rudling and M. Gardiner, *The South East to AD 1000* (Longman Group UK Ltd, 1988)

Dyer, J., *Hillforts of England and Wales*, (Shire Publications, 1992)

Dyer, J., *Southern England: An Archaeological Guide* (Faber and Faber Ltd, 1973)

Grinsell, L. V., 'The Barrows of the South Downs' in *Sussex County Magazine*, Vol. V, No. 6. (June 1931), pp. 396–401)

Holgate, R., *Prehistoric Flint Mines* (Shire Publications Ltd, 1991)

Holleyman, G. A., 'Bronze Age Farmstead on Itford Hill' in *Sussex County Magazine*, Vol 24 (1950), pp. 171–74

Kean, G. and T. Ketteman, *Sussex History Walks: The Downs Above Steyning* (Steyning Museum Trust, 1995)

Pollard, J., *Neolithic Britain* (Shire Publications, 1997)

Pull, J. H., *The Flint Miners of Blackpatch* (Williams and Northgate, 1932)

Reeves, H. L., *Adur to Arun* (Sheepdown Publications, 1970)

Reynolds, P., *Ancient Farming* (Shire Publications Ltd, 1987)

Roberts, M. and S. Parfitt, 'Boxgrove: A Middle Pleistocene Hominid site at Eartham Quarry, Boxgrove, West Sussex: No. 17' in English Heritage Archaeological Report Paperback 4 (October 1999)

Rudling, D., *Downland Settlement and Land-Use: The Archaeology of the Brighton Bypass* (Arhetype Publications Ltd, 2002)

Russell, M., *Flint Mines in Neolithic Britain* (Tempus Publishing Ltd, 2000)

Russell, M., *Prehistoric Sussex* (Tempus Publishing Limited, 2002)

Russell, M., *The Early Neolithic Architecture of the South Downs* (Archaeopress, 2001)

Sussex Archaeological Collections (SAC), Vols 1 to 159 (Sussex Archaeological Society, 1853 to 2021)

Toms, H. S., 'The Ancient Hill-Fort at Cissbury' in *Sussex County Magazine*, Vol. 1 (July 1927), pp. 350–53)

Vincent, A., *Neolithic Villages Near Worthing* (Alex Vincent, 2018)

White, S., *Archaeology Around Worthing* (Worthing Museum and Art Gallery, 1989)

Wymer, J., *Mesolithic Britain* (Shire Publications, 1991)

ACKNOWLEDGEMENTS

I wish to thank all those who have helped with the research for this book such as libraries, museums, record offices and other people for their information. I also wish to thank those other people and friends for the help they have given me. Special thanks go to Con Ainsworth, Martin Snow and Charles Walker.

A great thank you goes to the Sussex Archaeological Society and Worthing Museum and Art Gallery for giving me permission to use some of their black and white photographs. A special thank you goes to Worthing Museum and Art Gallery for allowing me to photograph some of their collection of finds.

The author by a Neolithic oval barrow in Stoughton Down.